GODS AND HEROES
IN POMPEII

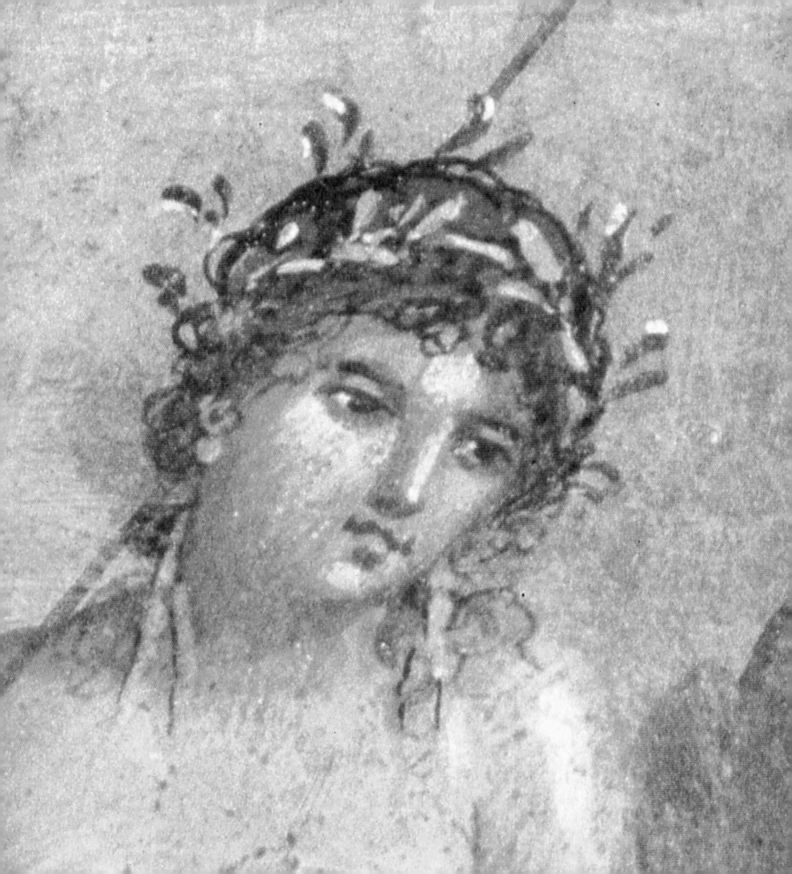

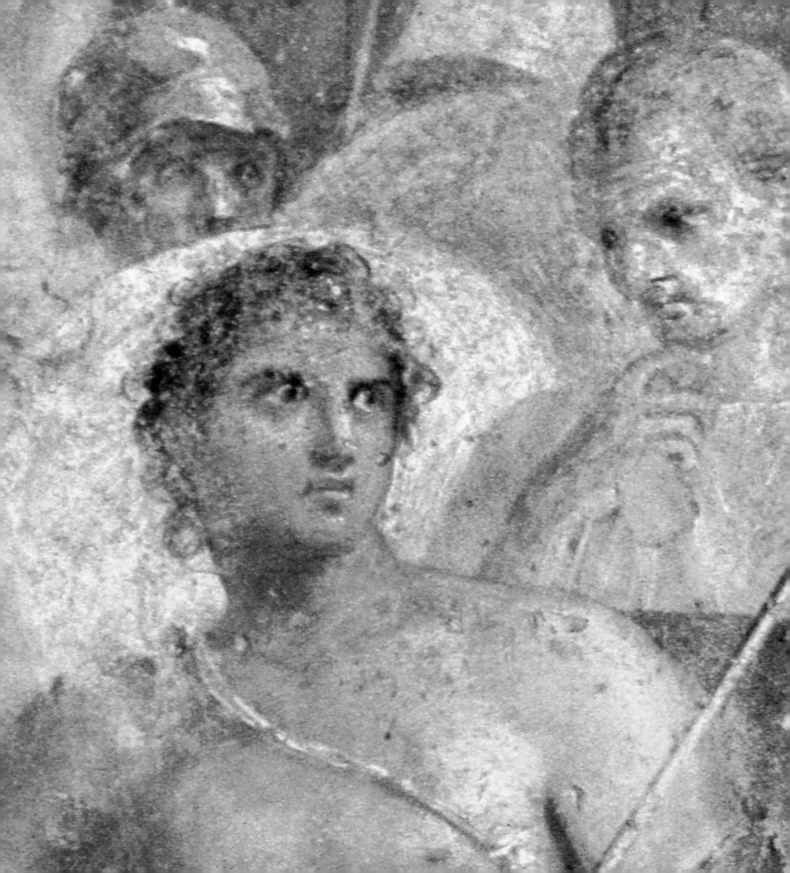

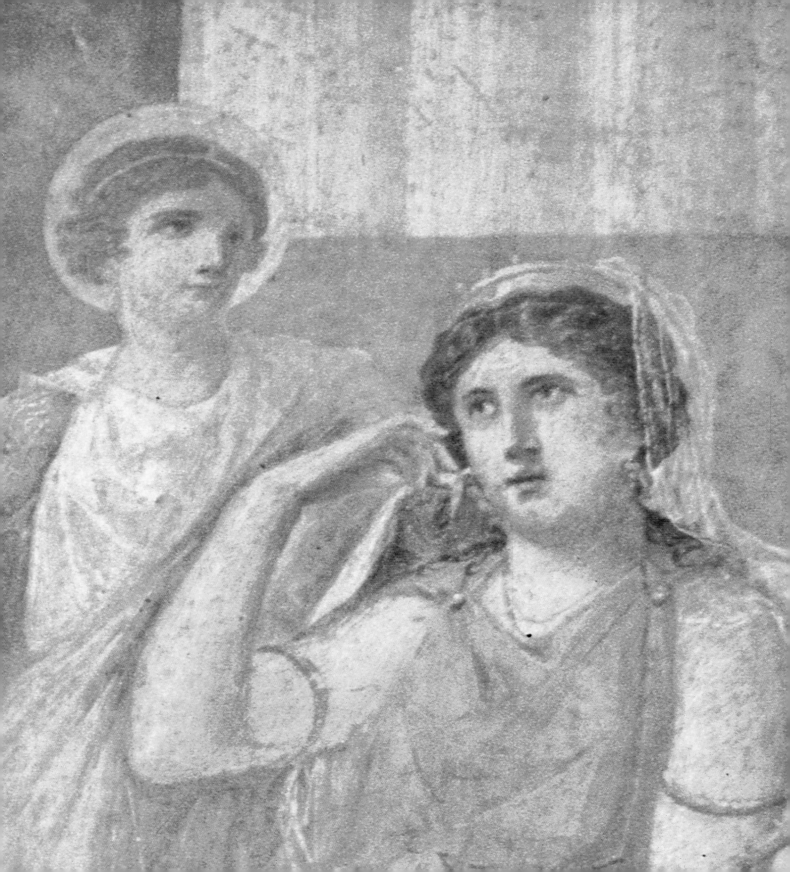

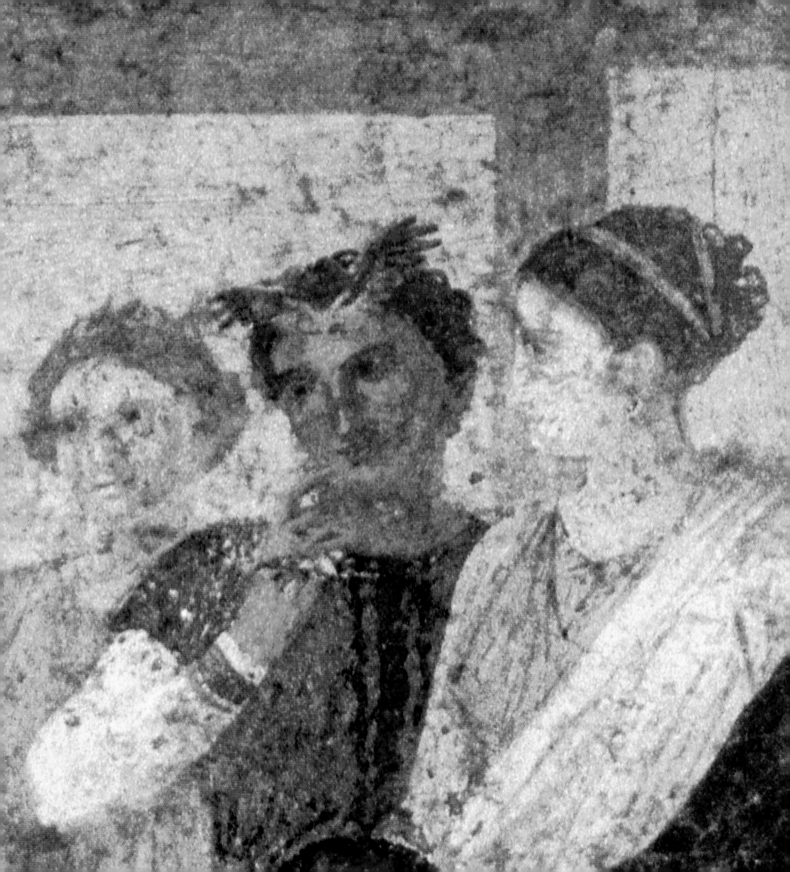

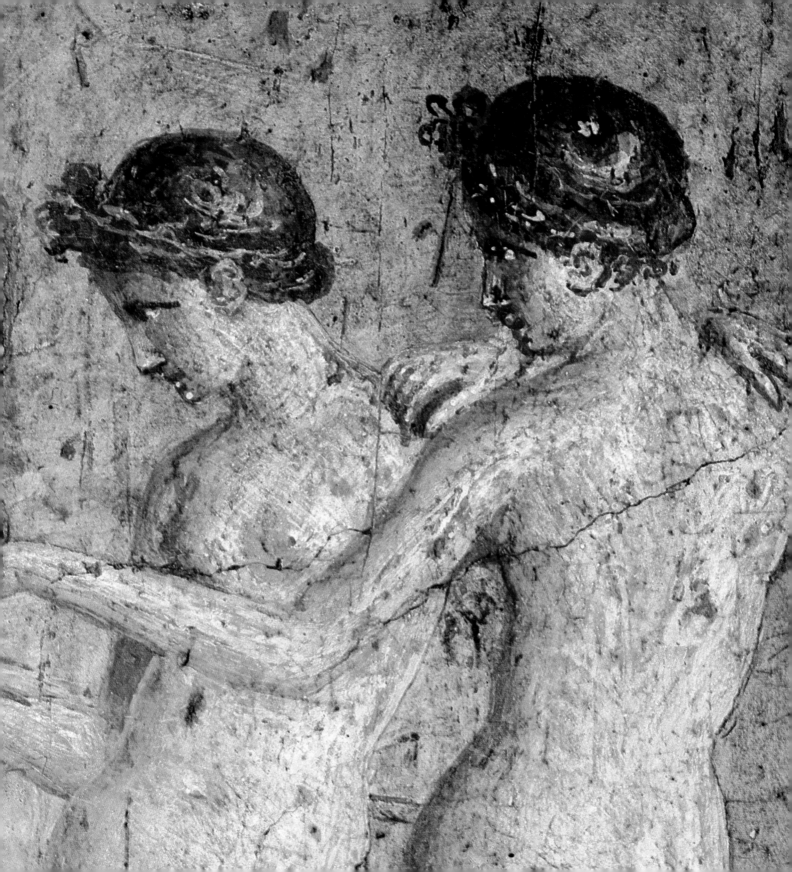

Ernesto De Carolis

GODS AND HEROES IN POMPEII

The J. Paul Getty Museum · Los Angeles

Ernesto De Carolis

Gods and Heroes in Pompeii

Translated by Lory-Ann Touchette

©2001 «L'ERMA» di BRETSCHNEIDER
Via Cassiodoro, 19 - 00193 Roma - Italia

First published in the United States of America in 2001 by
The J. Paul Getty Museum
1200 Getty Center Drive, Suite 1000
Los Angeles, California 90049-1687
www.getty.edu/publications

At the J. Paul Getty Museum:

Christopher Hudson, *Publisher*
Mark Greenberg, *Managing Editor*

Library of Congress Control Card Number: 2001091032

ISBN: 0-89236-630-3

Printed in Italy

On the cover:
Narcissus, Pompeii V.4.a, *Casa di M. Lucretius Fronto, cubiculum* no. 6, north wall

Photographs:
Alfredo and Pio Foglia, Naples

Thanks are due to:
Professor Stefano De Caro, Archaeological Superintendent of Naples and Caserta, and Professor Pietro Giovanni Guzzo,
Archaeological Superintendent of Pompeii

Note:
"MANN" in the text refers to the Museo Archeologico Nazionale di Napoli

CONTENTS **GENERAL CHARACTERISTICS OF POMPEIAN PAINTING**

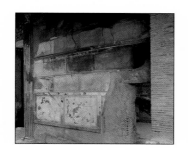

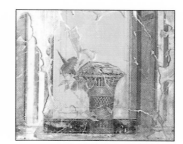

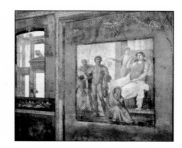

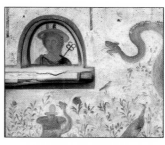

GODS AND HEROES IN POMPEIAN PAINTING - Catalog

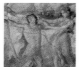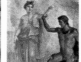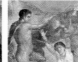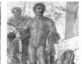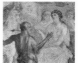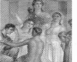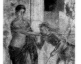

BIBLIOGRAPHY

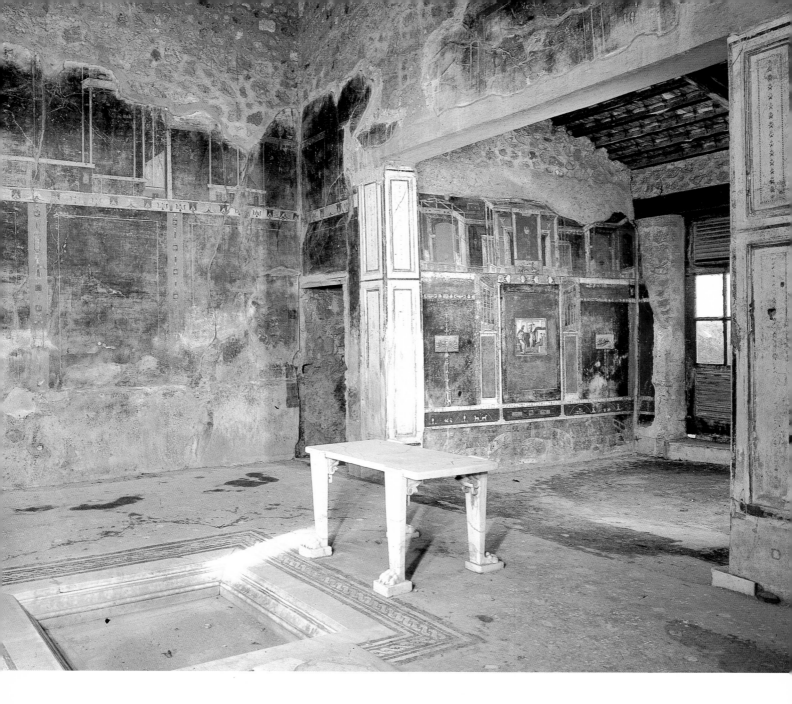

1. Pompeii V.4.a, Casa di M. Lucretius Fronto.
Wall decoration of the atrium and *tablinum*.

GENERAL CHARACTERISTICS OF POMPEIAN PAINTING

Of all the finds that the cities around Mount Vesuvius have preserved, the wall paintings and frescoes are particularly important due to their quantity and quality. The rediscovery of Pompeii and Herculaneum has made it possible to understand rather exhaustively—albeit through private and public commissions of provincial character—the development of Roman wall painting from the beginning of the second century B.C. to A.D. 79, when Mount Vesuvius erupted.

In fact, the great importance of the paintings found in the Vesuvian area lies in the opportunity they provide, unique in the reconstruction of the ancient world, to trace the development of pictorial taste over the uninterrupted span of three centuries. In addition, it is possible to follow this development within a single spatial framework composed of the urban centers, residential villas, and *villae rusticae* buried by Vesuvius's sudden eruption. Also unique is the possibility of attempting to discern, through the observation of contemporary paintings, the various local workshops from which the decoration of a dwelling was commissioned.

In the Roman world, the fashion for covering the walls with paintings cut across the entire society. Depending on their economic wherewithal, those who could afford a "dignified" residence turned to variously specialized workshops that were ready to execute whatever the commissioner requested.

With the exception of walls in areas intended for work or as housing for servants, nearly all the wall surfaces of Roman dwellings could be covered by pictorial decoration (fig. 1). The walls were simply whitewashed or, at most, embellished with geometric motifs executed with thin lines of color (fig. 2). The relationship that existed between a particular room's function and the subject or style of wall painting in that room, though very close, is not always perfectly definable.

In general, one can observe that in the private rooms of a house new fashions were easly welcomed; in contrast, in the reception rooms where guests were received, simplicity, and often conservation triumphs. In fact, it is significant that in A.D. 79, several prestigious houses displayed paintings of the First and Second Styles of Pompeian wall painting—dating, therefore, to the second to first century B.C. In A.D. 79, these lovingly preserved and restored wall paintings represented an unashamed exhibition of traditionalism, demonstrating to guests a family's antiquity (fig. 3).

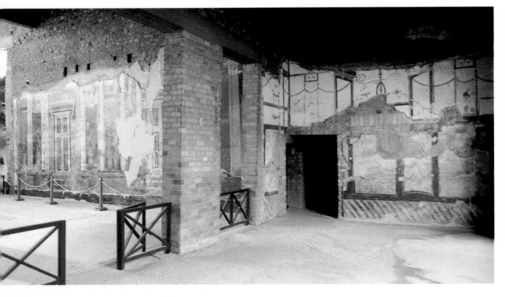

With the exception of those extreme examples, the pictorial decoration in a home's zones of passage, such as the entrance, atrium, and peristyle, is generally characterized by austere, often schematic and repetitive paintings. In contrast, in the living areas, such as the *tablinum* (main reception room), *triclinium* (dining room), and the *oecus* (alternative reception room or apartment), wall paintings reflecting a painter's fantasies and imagination achieved levels of high compositional and coloristic quality, evidently at the explicit request of the patron.

Beyond those general tendencies, we cannot ascertain a clear connection between the choice of pictorial compositions and the functions of the rooms in which they were placed. In rare cases, though, we are able to perceive a link—for example, in the presence of erotic scenes in *cubicula* (bedrooms) and in the intensification of Dionysiac compositions and still lifes in *triclinia* destined for banquets. This relationship may also be noted in the

2. Oplontis, Villa di Poppea, peristyle.
The wall decoration of the servants' area consists of vertical and horizontal panels filled with dark lines, probably imitating a marble surface with gray veins.

3. Oplontis, Villa di Poppea.
Second Style pictorial decorations appear in the atrium and Third Style in the rooms that demarcate the garden.

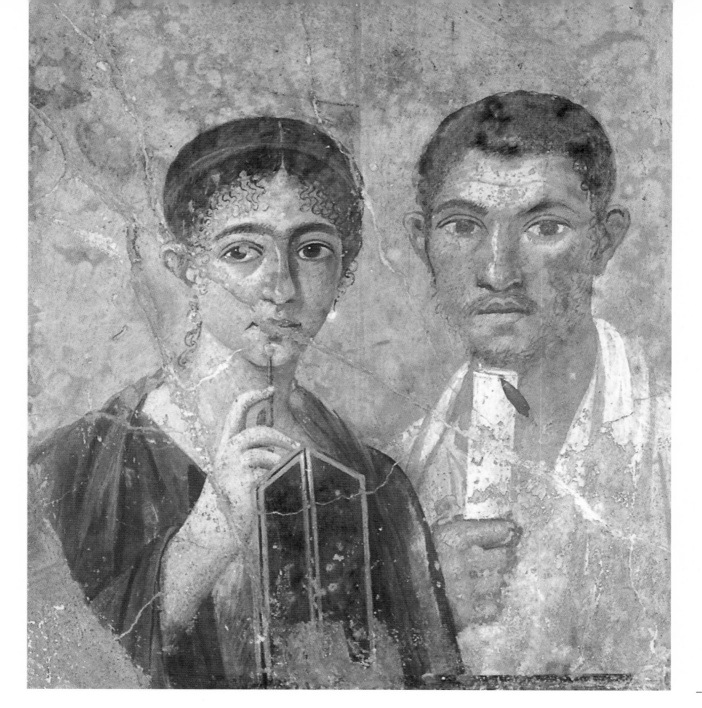

4. Pompeii VII.2.6, Casa di Terentius Neo, *tablinum* (MANN, inv. no. 9058).
The painter's attempt to insert these two figures into an elevated social class by flaunting their capacity to read and write fails immediately; the couple's facial features betray their provincial and working-class origin.

preference for garden paintings on walls adjacent to open areas, where such paintings create the illusion of a continuation of the space.

Similarly, it still needs to be verified that the decorative scheme of a house or of a single composition deliberately intended to convey a message about the patron's own image, about the role that he held in society, or even about his literary interests. The portrait of Terentius Neo with his wife (fig. 4) and the painting showing the free distribution of bread to commemorate the ascent in society of an artisan who became magistrate (fig. 5), both found in reception rooms, are exceptions. We do not have other known examples of pictorial messages. In addition, it is quite difficult to demonstrate that the many mythological representations in Pompeian houses reflect the owners' literary preferences.

However, in the case of artisan's workshops, commercial establishments, and places of refreshment, decorative compositions often directly relate to the activity exercised at the site. Such compositions fall within the style of so-called popular painting because of their simple and straightforward appearance. The Vesuvian area has preserved a precious nucleus of commercial signs and small didactic scenes illustrating various activities such as those tied to textile production, which was of fundamental importance to Pompeii's economy (fig. 6).

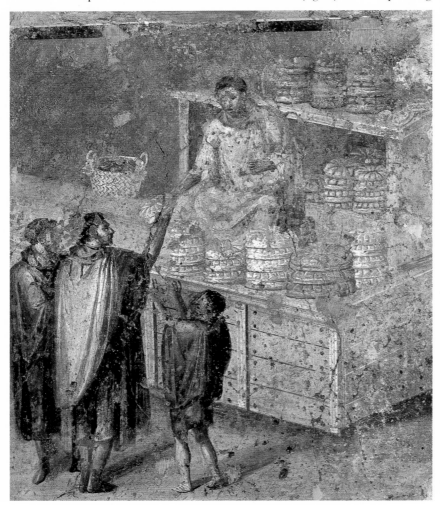

5. Pompeii VII.3.30, *tablinum* (MANN, inv. no. 9071).
This wall painting probably depicts a baker distributing bread for free on the occasion of his election to a public office. The baker, in a white toga, hands loaves to three people in traveling attire.

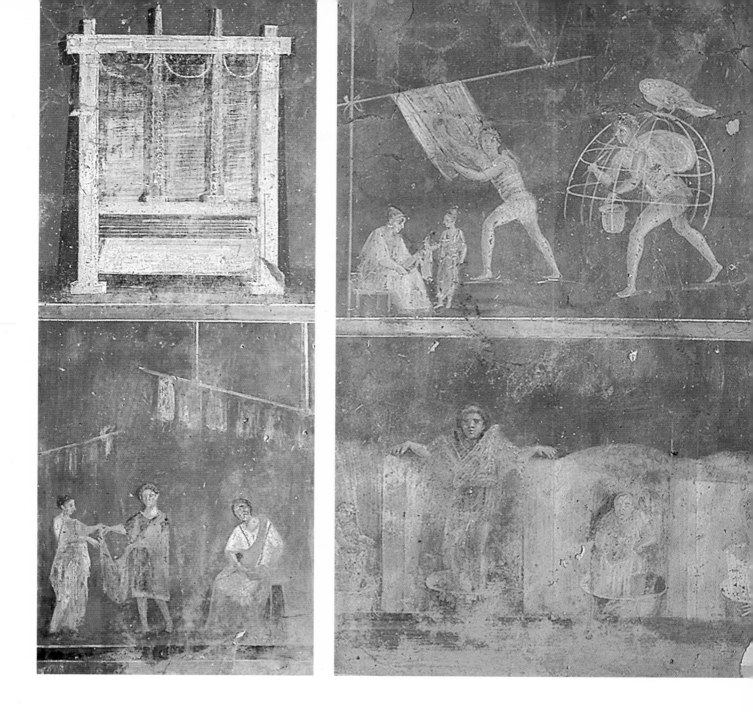

6. Pompeii VI.8.20, *Fullonica*, southeast pilaster of the peristyle (MANN, inv. no. 9774).
The pilaster, found in Pompeii's largest textile workshop, along Via di Mercurio, is decorated with scenes that illustrate different phases in the production of wool.

The study of wall painting was first addressed by August Mau, in 1882. On the basis of a famous passage in Vitruvius's *De Architectura* (VII.5.1-4, hereafter abbreviated *De Arch.*) and the substantial number of examples offered by the Vesuvian cities, Mau established a chronological succession and classified the wall paintings into four styles. This subdivision, improved and embellished by Hendrick Gerard Beyen in the first decades of the twentieth century and by a succession of studies, has not undergone substantial modifications. It is still used today, even though it seems more appropriate to define the four different manners that artists employed in covering the walls with decoration.

Transitional phases in the succession of the four styles have also been recognized, because of the chronological continuity of wall painting. In our overview of the wall paintings of the Vesuvian area, we shall consider the four styles in succession; then we will focus separately on two specific pictorial genres: garden paintings and popular paintings.

THE FIRST STYLE

An essential description of the First Style of Roman wall painting is found in Vitruvius: "The ancients who introduced the fashion of wall decoration at first imitated the different types of marble revetment and later the varied placements of cornices and blocks" (*De Arch.*, VII.5.1). Therefore we find ourselves faced with an imitation in stucco of structures and walls composed of horizontal rows of large rectangular panels simulating the slabs (orthostats) and thin rectangles imitating blocks (ashlar) seen from above or from the side.

These elements were executed in

7. Pompeii, Gate VIII of the city walls.
An example of First Style decoration, executed with horizontal rows
of ashlar in white stucco.

relief or incised and painted so as to imitate the variations in color of precious marbles, thus giving the wall a more important role from both the sculptural and chromatic points of view.

First Style decoration originated in the diversified Hellenistic world, especially in Greece and the eastern Mediterranean, from the fourth through third centuries B.C. onward. It was exported from there to the West and became established in the course of the second century B.C. It then completed its life cycle at the beginning of the first century B.C.

In Pompeii during the second century B.C., public and sacred buildings, the gates and towers of the city walls (fig. 7), and above all the residences of the wealthiest classes of Pompeian society of the period were decorated in the First Style. Among the numerous First Style walls preserved by Vesuvius's eruption in A.D. 79, two impressive examples include the walls at Torre di Mercurio (Mercury's Tower), on the Via di Mercurio, and at the Basilica, whose decoration probably dates to 130 to 120 B.C. The *Casa di Sallustio* (fig. 8) (VI.2.4) and the *Casa del Fauno* (VI.12.2), datable respectively to the second quarter and the end of the second century B.C., are private homes with noteworthy examples of First Style wall paintings.

The "Casa del Fauno" invites us to admire the great sophistication of the patron and the technical expertise of the workers who executed a decorative system of the First Style. The dwelling's entrance (fig. 9) presents, in addition to the customary rows of orthostats and ashlar animated with colors that imitate precious marbles, a projecting shelf used as a support for the façade of a temple, with a central door, preceded by four columns. In the first peristyle, the decoration of the walls respects the rhythm of the portico's columns by means of pilasters with smooth shafts that alternate with orthostats and rows of ashlar seen from above and the side. In the *Casa del Fauno*, the First Style thus achieves its most complete form, in which the wall not only imitates the structure of a wall but also reflects its true architecture, with shelves, cornices, architraves, pilasters, and columns.

With the First Style, we witness the birth of the vertical subdivision of wall decoration into socles, middle zones, and upper zones. Thus, the wall is characterized by a socle, normally formed by a high band of a single color; a middle zone, with high orthostats and rectangular ashlar; and an upper zone, again executed as a single band. Rare examples, such as in room 15 of the *Casa di Sallustio*, which is decorated with Ionic half-columns surmounted by a Doric frieze, and the previously mentioned entrance to the *Casa del Fauno* (see fig. 9), with its complex architectonic composition, are exceptions.

THE ANCIENTS WHO INTRODUCED THE FASHION OF WALL
DECORATION AT FIRST IMITATED THE DIFFERENT TYPES
OF MARBLE REVETMENT AND LATER THE VARIED PLACEMENTS
OF CORNICES AND BLOCKS.

VITRUVIUS, *DE ARCHITECTURA*

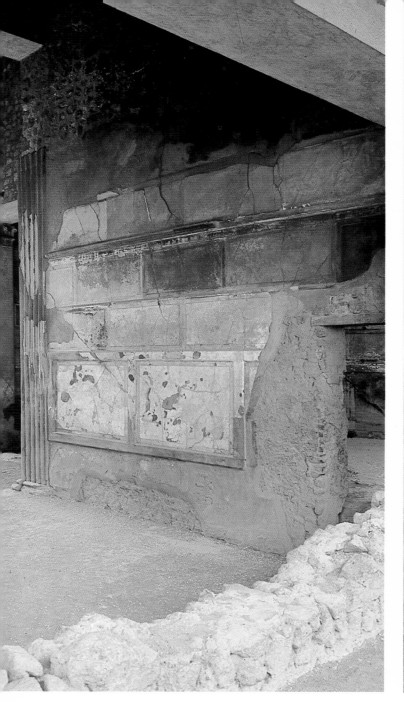

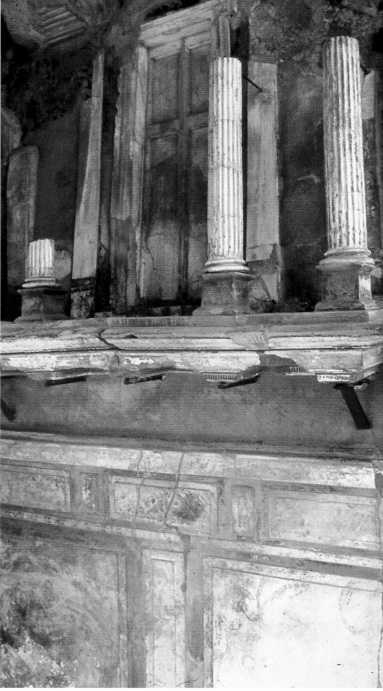

8. Pompeii VI.2.4, Casa di Sallustio, *tablinum*.
In this room, the socle is executed as a single band; the middle zone consists of orthostats with two rows of ashlar above. A molding separates those rows from another row of ashlar that is incised and filled in with color.

9. Pompeii VI.12.2, Casa del Fauno, entrance.
This example of First Style decoration exhibits unusually complex architectural details, both actual and illusionistic.

THE SECOND STYLE

Between the end of the second century B.C. and the beginning of the first century B.C., we witness the transition from the First to the Second Style. This new style followed a new pictorial fashion that probably began in Rome—the driving center of the expansion of new artistic trends— and then spread in contemporary society. A natural evolutionary process from the earlier style and the desire to visually imitate the sumptuous architecture of the Hellenistic palaces resulted in the birth and development of the Second Style. It should be mentioned, even if the argument still remains open, that a strong tie with theatrical scenography existed. According to a well-known passage of Vitruvius (*De Arch.*, V.6.9), it was fashionable to decorate some rooms of houses with paintings derived from theater backdrops corresponding to the three genres of tragedy, comedy, and satyric drama. These scenographies used movable panel paintings to define the setting in which the action took place. For tragedy, typical decorative motifs of an impressive royal palace with statues, columns, and elaborate entablatures were envisaged; for comedy, views of private houses; for satyric drama, landscape depictions with trees and grottoes.

Second Style wall decoration underwent a radical transformation. Thanks to the insertion of columns, architraves, cornices, and friezes, it used perspective to great visual effect. Through the multiplication of parallel planes, it almost achieved an imaginary breaking through of the wall itself. For the early and late phases of the Second Style, we also have a fundamental testimony in Vitruvius, who records how "later they began to imitate as well the forms of buildings, the projections in relief of columns and pediments" (*De Arch.*, VII.5.2).

Many frescoes in the Second Style come from the Vesuvian area, particularly from important residential villas, whose owners, as we have already noted, tended to conserve the paintings of preceding periods.

After the Second Style's initial phase, in which the breakdown of the wall concentrated in the upper part, around 60 B.C. we witness the maturation of this pictorial fashion involving the entire wall with spectacular compositional and chromatic effects. The *Villa dei Misteri* in the suburbs of Pompeii, the *Villa di Poppea* at *Oplontis* (figs. 10–11), the modern Torre Annunziata, and the *Villa di P. Fannius Synistor* at Boscoreale each provide vivid visual testimonies to the maximum expression of the Second Style in Vesuvian area. Colonnades, gates, multistory dwellings, balconies, terraces, and pergolas are superimposed on the wall,

sometimes with windows that open onto bucolic landscapes and gardens. The overall effect can almost visually demolish an entire wall.

At the end of the first century B.C., the Second Style entered its final phase. With an almost total detachment from architectural reality, pictorial representations were transformed into purely decorative and fantastic forms. It is precisely to these extreme manifestations, evidenced in the Vesuvian area in particular by a fresco found in a suburban villa in the outskirts of Herculaneum (fig. 12), that the ruthless criticism of Vitruvius refers. "But these figurative subjects, which were derived as copies taken from real elements, in our days

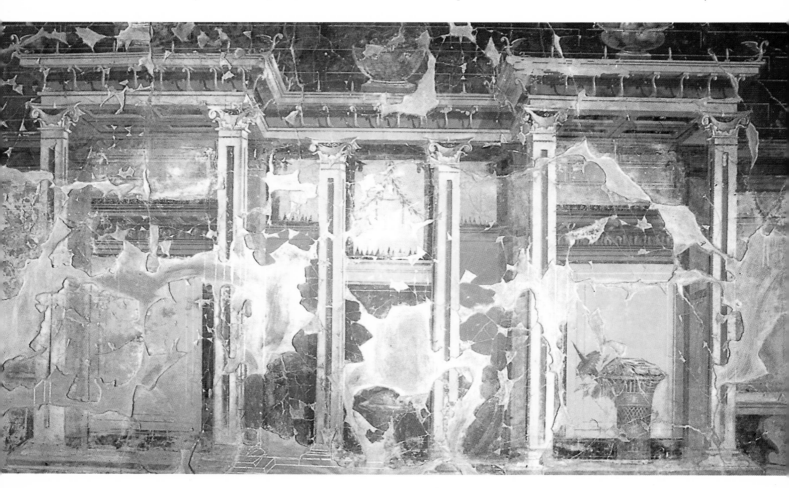

10. Oplontis, Villa di Poppea, *cubiculum* no. 11 11. Oplontis, Villa di Poppea, *oecus* no. 23

deserve disapproval on account of their spreading a depraved fashion. On the plaster are painted, in fact, monstrosities rather than precise images that conform to definite objects. Therefore, in the place of columns, reeds are painted; instead of pediments, ornamental motifs with curled leaves and volutes and then again candelabra that support images of small temples. . . . But these figures do not exist, cannot exist, have never existed" (*De Arch.*, VII.5.1–3).

Within the Second Style, a pictorial genre called megalography developed. This term is usually applied to representations depicting monumental figures within architecturally defined spaces. In these extremely rare

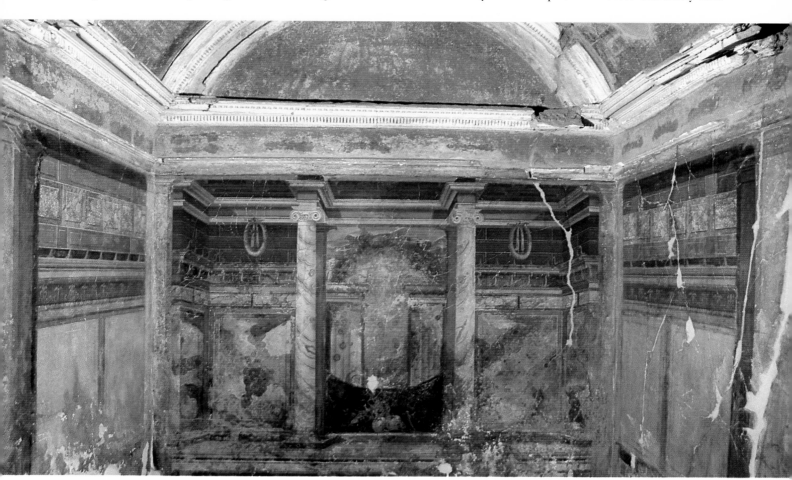

LATER THEY BEGAN TO IMITATE AS WELL THE FORMS OF
BUILDINGS, THE PROJECTIONS IN RELIEF OF COLUMNS
AND PEDIMENTS.

VITRUVIUS, *DE ARCHITECTURA*

12. Suburbs of Herculaneum, Villa near the Royal Stable, porticoes (MANN, inv. no. 8593).

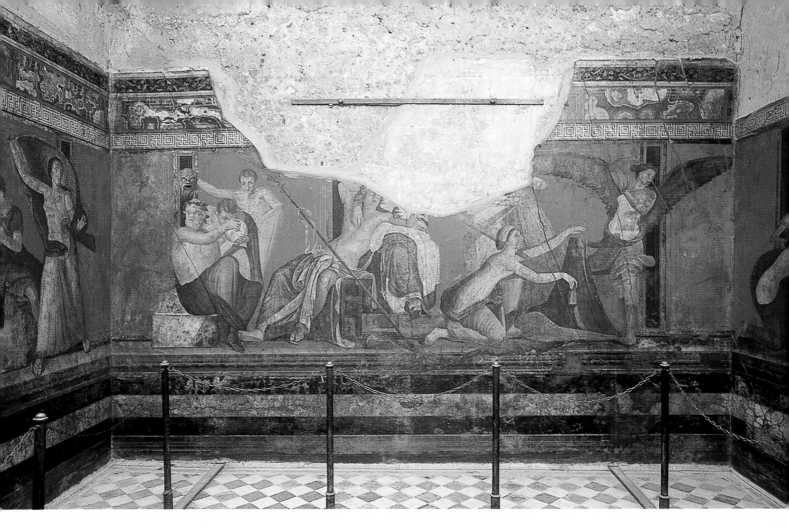

figurative compositions, the decorative scheme of the wall is subordinated to the representation of a specific action, liberally imagined by the artist.

The most famous example of these refined pictorial cycles comes from a suburban dwelling known as the *Villa dei Misteri* (fig. 13). The composition presents twenty-nine figures. It extends over all the walls of a room, interrupted only by a window, a small door communicating with an adjacent room, and another larger door that leads to an open arcade and the terrace of the hanging garden.

The architectonic decoration of the Second Style is here reduced to its essentials (in contrast with other rooms

13. Suburbs of Pompeii, Villa dei Misteri, *triclinium*.

of the Villa) and serves only as a background to the monumental figures. Thus, no element interrupts the development of the action, and the figures seem to gather and move freely in a defined space.

The interpretation of the entire scene in the *Villa dei Misteri* is still heavily debated. It is variously identified as the initiation rite of a bride in the Dionysiac mysteries, as a representation of rites tied to the professed faith of the proprietors of the Villa, as a reference to the cult of Dionysus himself, or as a theatrical representation.

THE THIRD STYLE

The pictorial evidence dating to between 20 B.C. (Augustan period) and A.D. 40–50 (Neronian period) demonstrates the genesis and diffusion of a new system of wall decoration called the Third Style.

Having abandoned the imposing and fantastic architecture that in the final phases of the Second Style occupied entire walls with elaborate quests for perspective, the new decorative system utilized a rigidly tripartite field divided into socle, middle zone, and upper zone. The middle zone presents large rectangular panels on a single background, separated by slender architectural and botanical elements. In the center, there are figurative motifs; the upper zone displays simple and schematic architecture. Third Style decorations are further characterized by two thin figured bands, called *praedella*, between the socle and the middle zone, and by a frieze between the *praedella* and the upper zone (fig. 14).

With the Third Style, the surfaces of the walls regain their original "solidity." In the initial phases, a remainder of "real" architectural elements is found in the *aedicula* (niche), with a pediment, supported by columns, that frames the central panel of the wall. Having passed beyond the organic vision of the decoration of a room typical of the Second Style, the viewer's attention is now directed to each individual wall and, in particular, to the central panel, where the principal decoration is found.

The fundamental Third Style innovation, which will be further developed in the Fourth Style, is the affirmation of figurative representation. The subjects are usually narrative-mythological ones set in the central panel of the middle zone, in the form of either a panel painting of large dimensions that expands in height, medallions, or single figures silhouetted on the background of the panels (fig. 15).

The painters' favorite themes communicate the stories of the gods (Dionysus, Aphrodite, Ares, Apollo),

14. Pompeii I.6.15, Casa dei Ceii, *atrium.*

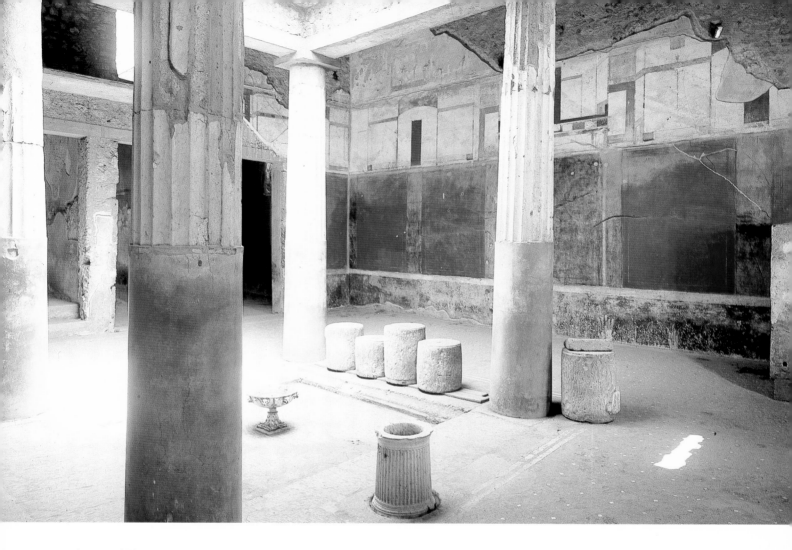

heroes (Theseus, Perseus, Achilles), and famous lovers (Polyphemus and Galatea, Paris and Helen, Meleager and Atalanta). Other subjects include theatrical scenes and sacred or idyllic landscapes.

Third Style compositions express, through Egyptianizing motifs, a fascination for an exotic faraway world. Such motifs became widespread in Roman art following the occupation of Egypt and the resulting increase in economic and cultural contacts there.

Over the course of years, the Third Style continued to evolve. Between A.D. 25 and 50, it reached a final phase in

HAVING ABANDONED THE IMPOSING AND FANTASTIC
ARCHITECTURE . . . THE NEW DECORATIVE SYSTEM UTILIZED A
RIGIDLY TRIPARTITE FIELD DIVIDED INTO SOCLE,
MIDDLE ZONE, AND UPPER ZONE.

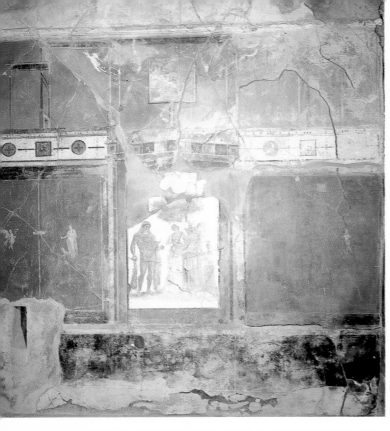

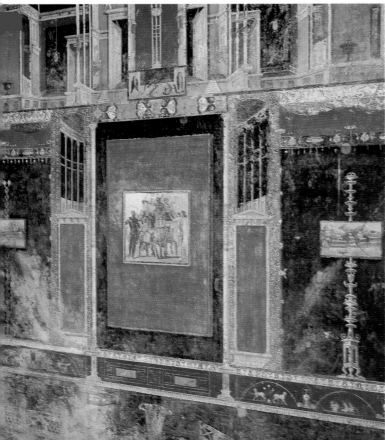

which order and simplicity progressively became corrupted, eventually resulting in a new decorative system called the Fourth Style.

Late Third Style wall painting exhibits an ever-greater complexity of elements, with the panels of the middle zone subdivided. This zone opens up again, giving glimpses of architectural perspectives. At the same time, the painting in the central panel is reduced in size until it almost takes the form of a small panel painting. This tendency also manifests itself in the upper zone, where fantasy and complex architecture achieves a greater sense of perspective.

The *tablinum* of the *Casa di M. Lucretius Fronto* (V.4.a) (fig. 16) at Pompeii provides the best-known example of this final phase, which is a prelude to the subsequent Fourth Style. In particular, the wall's socle is decorated here as a garden with an elaborate stockade open in the center, whereas the *praedella* presents depictions of miniaturist motifs. In the side panels of the middle zone of the wall, fantastic candelabra support small rectangular paintings. Flanking the central panel, where the painting of a mythological subject has been reduced to a square, the upper parts of narrow vertical panels depict fantasy architecture. Finally, the upper zone is characterized by refined architectural decoration that uses perspective, almost in imitation of a theater's *scaena frons*.

15. Pompeii I.7.7, Casa del Sacerdos Amandus, *triclinium*. Central *aedicula* with a panel painting depicting Heracles in the Garden of the Hesperides.

16. Pompeii V.4.a, Casa di M. Lucretius Fronto, *tablinum*.

THE FOURTH STYLE

The Fourth Style presents numerous problems for modern observers regarding both its origins and its subsequent evolution or division into trends. In-depth research has not yet furnished definitive explanations. Nevertheless, we can assert that this new pictorial system arose in the Vesuvian area in the years immediately following the middle of the first century A.D. Its development was a result of artistic impulses from Rome that originated in particular from the decoration of the famous *Domus Transitoria*, the first imperial palace built by Nero.

The Fourth Style's wide diffusion throughout the Vesuvian area was due in large part to the destructive earthquake of A.D. 62. As houses were restored and made habitable again, damaged pictorial decorations were replaced with newer wall paintings.

Two compositional trends have been identified in the Fourth Style. The first, called *scaenae frontes* (stage background), originated in the scenographies that had probably been at the roots of the illusionistic Second Style; the second is considered an evolution of the Third Style.

In the *scaenae frontes* of the Fourth Style, compositions cover the entire wall with complex and sumptuous architecture displaying vast openings; entire figures appear in the foreground. A refined example in the *Domus Aurea*,

17. Pompeii V.4.a, Casa di Pinarius Cerealis, *cubiculum* a, north wall.
The composition shows Iphigenia in the center, followed by two priestesses; on the right are Orestes and Pylades with their hands tied behind their backs; the king of Thrace, Toantes, is seated on the left.

18. Pompeii VI.8.23, Casa della Fontana Piccola, *ala*, north wall.

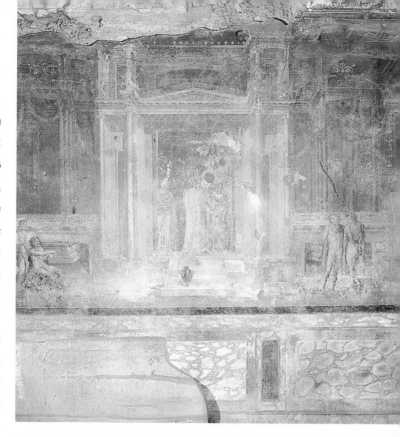

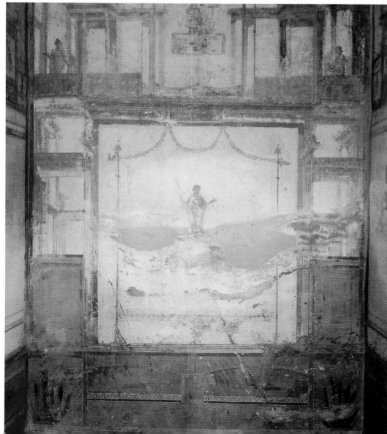

Nero's second imperial palace, whose construction began in A.D. 64, is known through a drawing made in 1776. In this type of composition, the walls are not divided into middle and upper zones, although sometimes a socle is painted to imitate the marble that must have been used instead on walls of this type in the *Domus Aurea*. In the Vesuvian area, examples of Fourth Style wall decorations in the style of a *scaena frons* are rare. We can cite the refined examples present in a *cubiculum* of the *Casa di Pinarius Cerealis* (III.4.4) (fig. 17) and the central hall of the so-called Palaestra (VIII.2.23).

In contrast, many Pompeian frescoes (see, for example, those in figs. 18–20) exhibit the second pictorial trend of the Fourth Style, which is derived directly from the Third Style of decorative wall painting. In these

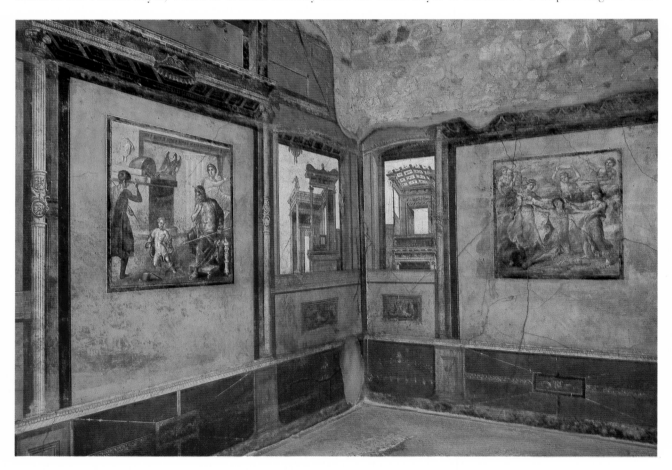

19. Pompeii VI.15.1, Casa dei Vettii, *triclinium* n.
The central panels depict the infant Heracles strangling the serpent
(north wall) and the murder of Pentheus (east wall).

wall paintings, the wall's middle zone is subdivided into panels, with paintings and figures in flight delimited by borders and separated by elaborate architectural perspectives of often strongly fantastical character. In contrast, the upper zone is articulated with complex pavilions and architectural wings enriched with fantasy figures and decorated with stucco frames.

Private patrons favored this type of highly refined wall painting, using it to lavishly decorate their houses. Many walls now preserved in the Vesuvian area exhibit this compositional trend, including, for example, the decorative scheme of the *Casa dei Vettii* (VI.15.1). Fourth Style wall paintings assume a sumptuous and fantastic aspect, rich with strong chromatic contrasts, in which the reality of the architecture and the significance of the figures disappear, leaving room for a purely decorative intent with meticulous attention to the smallest details.

The eclectic range of Fourth Style painting prompted local pictorial workshops to fully develop their decorative capacity, thereby achieving perhaps their best expression.

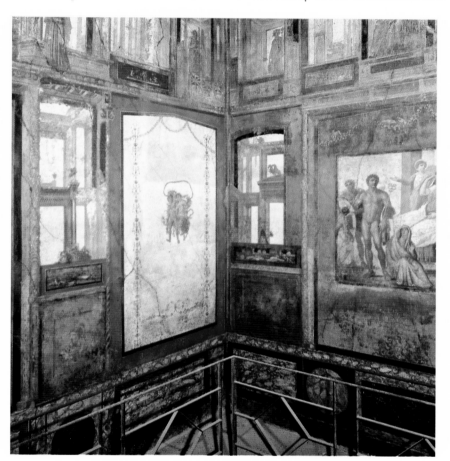

GARDEN PAINTING

Representations of gardens are an important part of Vesuvian pictorial remains.

In typical Pompeian garden scenes (see figs. 21–23), a low stockade is set in the foreground; behind it grows a luxuriant garden formed from a wide variety of flowering plants. In

20. Pompeii VI.15.1, Casa dei Vettii, *triclinium* p.
The east wall contains the central panel with the painting depicting the punishment of Ixion.

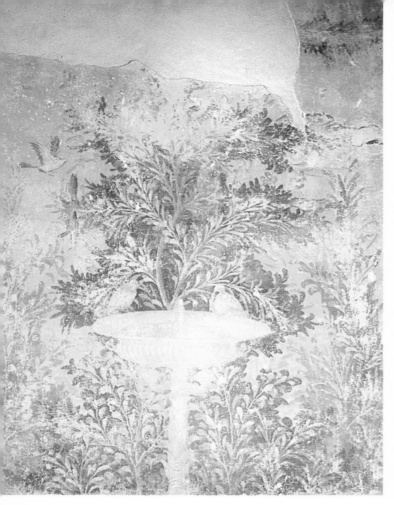

many garden paintings, birds fly among the vegetation or pose on the branches. Sometimes the scene below includes craters and fountains with square or circular basins and supports in the form of centaurs or harpies. Garlands in the form of theater masks often adorn the wall above the garden scene. Reclining Silens, nymphs bearing vases, Egyptianizing figures, and small *pinakes* (illusionistic panels with doors), often showing Dionysiac motifs, commonly inhabit Pompeian garden paintings.

In the Vesuvian cities, these paintings are found almost entirely in private houses; they rarely occur in public buildings.

21. Oplontis, Villa di Poppea.
The rooms on the sides of the distyle room no. 69 present refined garden paintings on a yellow background.

22. Pompeii I.9.5, Casa del Frutteto, *cubiculum* **no. 8.**
East wall with depiction of lemon trees.

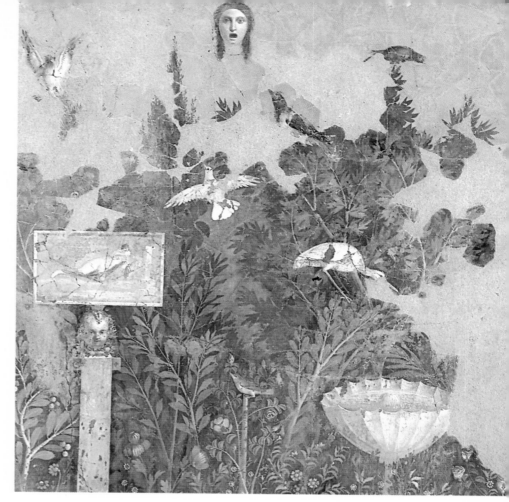

Garden scenes first appeared in Roman Third Style paintings. They then developed more widely in Fourth Style decorative schemes. As mentioned earlier, in Fourth Style compositions the wall is subdivided through the use of fantasy architecture rendered in perspective, both in the wall's upper zone and as an element for dividing panels in the middle zone.

Fourth Style compositions originated not so much in the Vesuvian cities as in Rome at the end of the first century B.C., as the discovery of the famous frescoes in Livia's Villa at Prima Porta attest. Although we can therefore affirm that the Fourth Style paintings appeared first at Rome and then in the provinces, the origin of garden paintings is not as certain. Nevertheless, it is logical to hypothesize that these distinctive compositions had their roots in the Hellenistic world, in particular in the landscape trends of Alexandrian origins and in the strong taste for illusionistic scenographies.

Moreover, the Roman desire to pictorially represent the famous illusionistic *paradeisoi* (wild animal parks) of faraway Iranian origin also contributed to the birth of this genre. *Paradeisoi* were characterized by the presence of a symmetrical cultivated area flanked by a wild and wooded property.

All these elements—together with a love of nature typical of the Romanized Etrusco-Italic world—combined to finally complete a form of artistic expression that up to then had not yet been fully realized.

23. Pompeii VI.17. *Ins. Occ.*, 42. Casa del Bracciale d'Oro, room no. 32, south wall.

POPULAR PAINTING

Most wall paintings found in the Vesuvian cities can be divided into two groups: paintings that present stylistic and compositional characteristics derived from the grand Hellenistic pictorial schools and paintings with independent characteristics traceable to the Italic artistic world.

To the first group belong the architectonic decorative system of the walls (the Four Styles), which embraces various subjects (for example, mythological subjects, landscapes, still lifes), in addition to the megalographies and garden paintings.

The second group consists of paintings of "local subject matter." They portray episodes of real life, depict arts and crafts, or function as shop signs; they show processions and ceremonies in honor of deities and depict the *Lares*

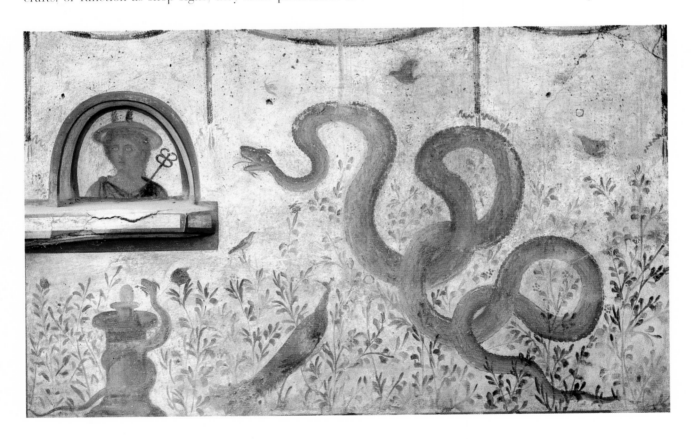

24. Pompeii I.6.2, Casa del Criptoportico, peristyle.
Lararium with a bust of Hermes within a niche and the serpent Agathodaimon.

(household gods). The main characteristic of these compositions is how different they are from the preceding group of paintings: the absence of compositional unity in the scenes immediately strikes the viewer. The figures appear unconnected, almost without relationship to one another. They are isolated on a non-specific, usually white background. Finally, the compositions exhibit a marked indifference to the representation of spatial and dimensional relationships.

The various elements that differentiate this second group from other types of Vesuvian wall paintings share one important characteristic: they are aspects of Italic and, subsequently, Roman taste that remained unaffected or only marginally affected by the Greek artistic tradition. Together, compositions of this type are called "popular paintings." They are popular not in the sense of being reduced and impoverished as compared to what was depicted in Hellenistic painting but in the sense of being a product that sprung from a local world. This style expressed itself with a reduced range of colors in a simple, immediate manner without high artistic aspirations.

Pompeii has preserved a substantial number of popular paintings, largely on the exteriors of houses and shops. Only rarely were they placed within buildings, the exception being popular paintings associated with *lararia*, or household shrines. Most popular paintings

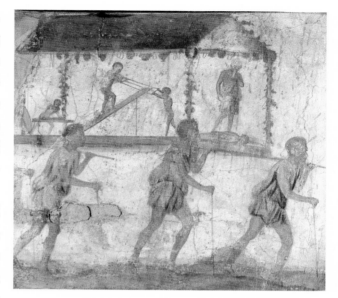

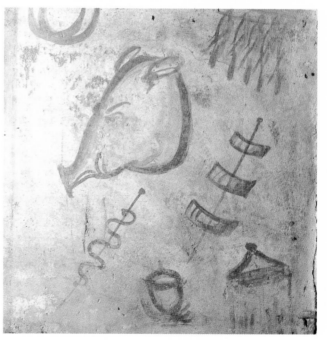

25. Pompeii VI.7.8, façade (MANN, inv. no. 8991).
Shop sign with a procession of carpenters transporting a canopy on which there is the image of the mythical craftsman Daedalus and several people intent on woodworking.

26. Pompeii IX.9.b/c, Casa di G. Sulpicius Rufus, kitchen.
Detail of the painting of a *lararium* characterized by the unusual representation of food ready to be cooked, including hanging sausages, a pig's head, an eel, and portions of meat on a spit.

date to the last years of the life of the Vesuvian cities precisely because of the character and purpose of this type of painting.

Even with its inconsistencies and unique characteristics, popular painting—through the images of the *Lares* (fig. 24), processions (fig. 25), arts and crafts, and episodes tied to daily life (fig. 26)—affords a powerfully realistic glimpse of the period. Popular painting allows us to better understand aspects of daily life and private religious sentiments of Pompeian society.

PAINTING TECHNIQUE

To understand how pictorial decoration was executed, we have as a resource not only the large quantity of examples preserved in the Vesuvian cities but also the fundamental contribution of the Roman writer, architect, and engineer Vitruvius. In book seven of his ten-volume treatise *De Architectura*, written in the first century B.C., Vitruvius describes with great precision how ancient artisans prepared and painted a plaster wall:

"When it has been preceded by the application of not less than three layers of sand mortar, in addition to the plaster, it is necessary at this point to spread layers of large-grained marble dust, with the mortar mixed, until, when it is laid on, it does not attach itself to the trowel. . . . Having spread this layer of large grains, when it has dried, a second of medium thickness is applied. When this has been pressed and well polished, a thinner one is applied. In this way, reinforced with three layers of sand mortar and as many of marble dust, the walls cannot develop cracks or some other imperfections. But once the wall's compactness has been consolidated, polished with levels, and smoothed with the marble gleaming and sound, the walls radiate the most brilliant gloss. Afterward, together with the final finishing touches, the colors were spread.

"As far as the colors, when there had been the wisdom to spread them on the still-damp facing, they do not fall off but remain permanently fixed. This is because the lime, having become porous and therefore insubstantial after its liquid component has been dried up in the kiln, as if compelled by the dryness, absorbs whatever comes into contact with it. It mixes with the constituent elements drawn from the other substances, forming a solid mass. . . . When it becomes dry, this is reconstituted, so as to demonstrate itself in possession of the qualities particular to its nature.

> WHEN IT HAS BEEN PRECEDED BY THE APPLICATION OF NOT LESS THAN THREE LAYERS OF SAND MORTAR, IN ADDITION TO THE PLASTER, IT IS NECESSARY AT THIS POINT TO SPREAD LAYERS OF LARGE-GRAINED MARBLE DUST. . .
>
> VITRUVIUS, *DE ARCHITECTURA*

"Therefore, the facings that have been executed correctly do not become rough with the passage of time, nor when they are washed do they allow the colors to peel off, at least if these last were not spread with little care and on already dry surfaces. When, therefore, the facings in the walls have been done according to the procedure that has been described earlier, they could have not only solidity but also a splendid appearance and an excellent quality intended to last in time" (*De Arch.*, VII.3.6–8).

The procedure Vitruvius describes so exhaustively provides, therefore, for the application to the wall of seven layers of plaster. The first layer (*rinzaffo*), made of lime and course-ground sand, is followed by three intermediate layers (*arriccio*), made with finer-grained sand. The final three layers are created by mixing lime, in this case aged for a maximum of eight months, either with very fine marble dust or with calcite, which was obtained by crushing limestone. (Calcite was used more often than marble dust because it was more economical.) To polish the wall, artisans employed an instrument formed of a square board with a handle in the center. Afterward, the color was spread on the still-fresh plaster. Slaked lime contained in the plaster reacted with carbon dioxide in the atmosphere, forming a thin film of lime carbonate that made it possible to permanently fix the colors.

In another passage of *De Architectura*, Vitruvius describes a different procedure, known as encaustic, which protects cinnabar (mercuric sulphide of vermilion red). This color, as well as others, could not be adopted in fresco painting because it reacted with the lime present in the plaster.

"But whoever is more accurate and should wish a decoration of cinnabar that conserved the original color must apply with a paintbrush Punic wax liquefied with fire and diluted with a bit of oil, after the wall has been painted and has dried. . . . Coal placed in an iron container caused this wax to transude with the wall, reheating it from nearby, so as to render the surfaces the same. Finally, it was polished with a candle and clean linen cloth. . . . This procedure is called *ganosis* in Greek. In this way, the protective facing of the Punic wax, creating an obstacle, prevented both the splendor of the moon and the rays of the sun from taking the color away from this decoration, fading it" (*De Arch.*, VII.9.3).

Thanks to this operation, through which the oil and the wax neutralize the lime's causticity, it was possible to maintain the red color without alterations. This passage from Vitruvius, which refers only to cinnabar, has led to the widely held hypothesis that, after ancient artisans had finished painting and polishing a wall, they then spread a layer of

wax on the finished product to give gloss to the pictorial decoration. As recognized by Vitruvius, this final waxing is thought to have also served a protective function.

Studying the many Vesuvian wall paintings that have been conserved has allowed us to augment Vitruvius's description. For example, we now know that colors were often superimposed on those applied when the fresco was still fresh. These added colors were mixed with an organic binder, not always identifiable today, or else with lime to permit a new carbonization, which was then spread on the wall.

We also know that the seven layers of plaster Vitruvius described constituted a maximum that was only rarely put into practice. In fact, the pictorial workshops in the Vesuvian area usually applied two to four layers of plaster, reaching a maximum thickness of 9 cm, preparatory to painting on a wall, with the result lasting in every case.

The colors utilized by the pictorial workshops and amply described by Vitruvius in *De Architectura* (VII.7.7-14) and

by Pliny the Elder in *Natural History* (35.29–50, hereafter abbrebiated *N.H.*) were natural pigments. Some, such as cinnabar and blue, required careful and complex preparation in the workshop, mixing together more than one element. In the ancient world, it was customary to distinguish the dark colors (*austeri*) from the bright ones (*floridi*). These last, being particularly precious, were expensive. To avoid having colors of inferior quality substituted during course of the work, a patron would often purchase those expensive pigments himself and then consign them to the pictorial workshop chosen to decorate his dwelling. Once the plaster on the still-fresh surfaces had been prepared, points of reference were established using lines marked with a string; light geometric incisions were then drawn with a compass or a pointed instrument. Alternatively, as one can see in several examples conserved in the Vesuvian area, a drawing was traced in a dark brown color. The painter began painting at the top, covering a section of the wall with color. The wall's extent was determined

27, 28. Pompeii I.6.4, Casa del Sacello Iliaco, *cubiculum* h.
The incomplete north and south walls show the successive layers of plaster applied before laying the colors. Only the upper zone is finished, furnishing a clear example of a "day's work," or *pontate*.

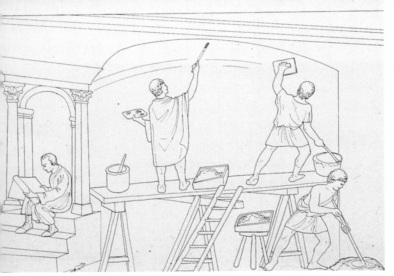

by how much of it could be painted in a single workday: it was necessary for the plaster to remain fresh while the pigment was applied (figs. 27–28).

These sections, which took the name of "a day's work," or *pontate*, often coincided with the vertical, tripartite division of the wall into upper zone, middle zone, and socle. In the case of large walls or those with complex decoration, the breaks could also follow the course of the partitions of a composition.

Many painting workshops were active in the Vesuvian area (fig. 29). Within them, artisans specialized in architectural or generic decoration *(pictor parietarius)* as well as panel paintings *(pictor imaginarius)*. In producing the latter, which were certainly the most sought after, artisans very often used so-called cartoons. These were more or less faithful reproductions of famous Greek panel paintings on easels. In rare cases, the compositions were executed on plaster panels inserted in wooden frames and later placed in the center of the wall, as documented by several examples from Herculaneum. Signatures of painters do not survive, with the exception of a single case *(Lucius pinxit)* found in the *Casa di D. Octavius Quartio* at Pompeii (II.2.2). Moreover, the painters did not have true creative autonomy; in general, they copied decorative schemes or figurative compositions from the Greco-Hellenistic world according to the needs of the patron, adapting them to the architecture and function of the rooms. Therefore, for the most part we see craftsmanship of very high quality, but not the work of creative artists. Indeed, contemporary observers held wall painting in only modest regard. Pliny the Elder, in fact, recorded that true glory was reserved only for the artists who created panel paintings *(N.H.,* 35.118).

29. Sens, stele datable to the second century A.D. depicting a team of decorators painting a wall.

GODS AND HEROES
IN POMPEIAN PAINTING

Catalog

GODS AND HEROES IN POMPEIAN PAINTING

In April of 89 B.C., the Roman army led by Lucius Cornelius Sulla attacked Pompeii and forced the city to surrender. It was then occupied militarily. Some years later, in 80 B.C., to favor the veterans who had fought with him during the distribution of the confiscated lands, Sulla reduced Pompeii to a colony. The colony was given the name of *Colonia Cornelia Veneria Pompeianorum*, tying Sulla's *gentilicium* (nomen) to Venus, the goddess particularly venerated by him, who therefore assumed the role of protectress of the city. The *deductor* of the colony was General Sulla's nephew, Publius Cornelius Sulla, an eminent politician of the Ciceronian period.

This "political" cult of Venus, imposed by the conquerors, came to be grafted onto an earlier one of the pre-Roman period that was rendered to the goddess with the epithet of Physica, linking her to the force of nature with the prerogative of fertility and abundance.

In fact, representations of Venus (known to the Greeks as Aphrodite), enjoyed great success in wall painting on the exterior and interior of the buildings, both in scenes more strictly tied to religious ceremonies or to the protection of work activities and in panel paintings of mythological subject matter. In a world by now at peace and in a wealthy city such as Pompeii, the depiction of Aphrodite was tied above all to the elegant and refined depiction of the most erotic episodes of myth. For example, Aphrodite is shown encouraging Helen in the seduction of Paris (I.7.7, *cubiculum*), leaning voluptuously against Ares after having convinced him to lay aside his arms, which the Erotes irreverently play with (VII.9.47, *tablinum*), or assisting the hunter Adonis, who is wounded mortally with compassionate love (VI.7.18, *viridarium*).

The theme of love sees numerous other protagonists in Vesuvian wall paintings. Zeus appears in his multiple transformations, for example as a swan or bull. Artemis is spied on by Actaeon while she is bathing (II.2.2, pergola). Io, the beloved of Zeus, and because of this guarded by Argos (VI.9.2, *tablinum*), is also represented.

The heroes themselves do not escape from this seemingly inexhaustible source of inspiration for painters, and their deeds are frequently represented. Perseus is shown engaged in the liberation of a bound Andromeda from the clutches of a sea monster (VI.9.6, peristyle). Theseus, who abandoned Ariadne on a deserted island, where she was later saved by Dionysus, is another favorite subject (I.4.5, exedra).

Pompeian painting does not, however, ignore the tragic stories of mythological figures struck by ill fortune. Medea, seeking revenge for her abandonment by Jason, is represented meditating on the murder of their children

EACH OF US HAS WELL-KNOWN PHYSICAL FORMS.
FROM FLOWING LOCKS IT IS APOLLO, HERCULES IS
MUSCULAR, YOUNG BACCHUS IS ENDOWED WITH A VIRGINAL
FIGURE, MINERVA HAS GRAY EYES, VENUS LANGUISHING ONES.
CARMINA PRIAPEA

(VI.9.6, peristyle). Other themes include the terrible punishment of Dirce (VI.15.1, *triclinium*); Admetus unhappily surprised to learn that he must die (Herculaneum); Phaedra's love for her stepson Hippolytus (VI.9.6, *viridarium*); and the suicide of two Babylonian lovers, Pyramus and Thisbe (II.2.2, *biclinium*).

The fascinating deeds of the heroes in Homer's epics must have had great success among patrons. Those subjects are found in many compositions, such as scenes from the *Iliad* in the *Casa del Poeta tragico* (VI.8.3): the marriage of Zeus and Hera, the departure of Chryseis, the handing over of Briseis, and the sacrifice of Iphigenia.

In contrast, in the *Casa del Menandro* (I.10.4, ala), a triptych was painted on three different walls of a room depicting key episodes in the conquest of Troy: the death of Laocoön and his sons; Cassandra and the Wooden Horse; Priam between Helen and Cassandra.

In addition, several large Iliadic friezes, unfortunately very fragmentary, are strictly tied to these compositions. The most important of these are in the *Casa del Criptoportico* (I.6.2, cryptoporticus), arranged in numerous painted panels with different episodes. The panels begin with the plague in the Achaean camp down to the flight of Aeneas from Troy. The *Casa di D. Octavius Quartio* (II.2.2, oecus) includes two friezes, on above the other. The upper frieze shows the Trojan adventures of Heracles and Laomedon; the lower one portrays the funerary games in honor of Patroclus and the ransoming of Hector's body.

Subjects derives from Virgil's reworking of the myth of Aeneas rarely occur in Pompeian wall painting. The few that are extant include one showing the hero while he is cured by a doctor (VII.1.25, *triclinium*) and another depicting Aeneas fleeing Troy in flames with his father Anchises and his son Ascanius (IX.13.5, external façade).

 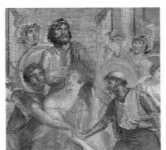 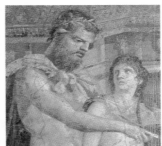 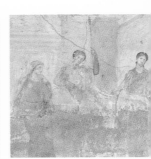

Aphrodite

Pompeii II.3.3, Casa della Venere in Conchiglia, peristyle, South wall; Fourth Style

The goddess of love, conceived by Zeus and Dione, emerged nude from the foam of the waves. Navigating on the valve of a seashell, she stopped first on the island of Cythera and then went to Cyprus, where she established her residence. This Pompeian image, of Hellenistic origin, shows the goddess reclining, her shapely body richly jewelled, with a fan and veil, swollen by the wind like a sail. Aphrodite is escorted by Erotes, one of which is astride a dolphin.

Wedding of Zeus and Hera

MANN inv. no. 9559, Pompeii VI.8.3, Casa del Poeta Tragico, atrium no. 3, South wall; Fourth Style

Hera, the daughter of Chronos and Rhea, was courted unsuccessfully by Zeus, who transformed himself into a cuckoo to achieve his aims. Hera was touched by the bird and captured it to warm it with the heat of her body; Zeus, having resumed his true appearance, raped her and forced her to marry him. This painting shows the marriage between Zeus and Hera on Mount Ida. The god sits majestically on a rock while extending his arm to take one end of the nuptial veil carried by Hera. Behind Hera's shoulder is a winged genius.

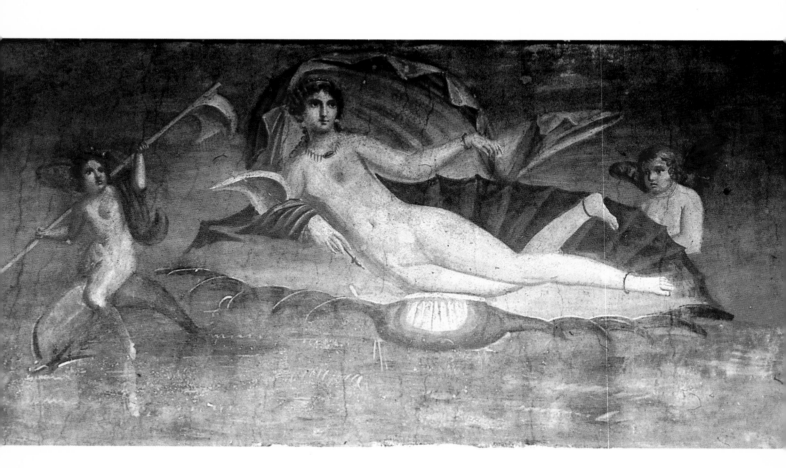

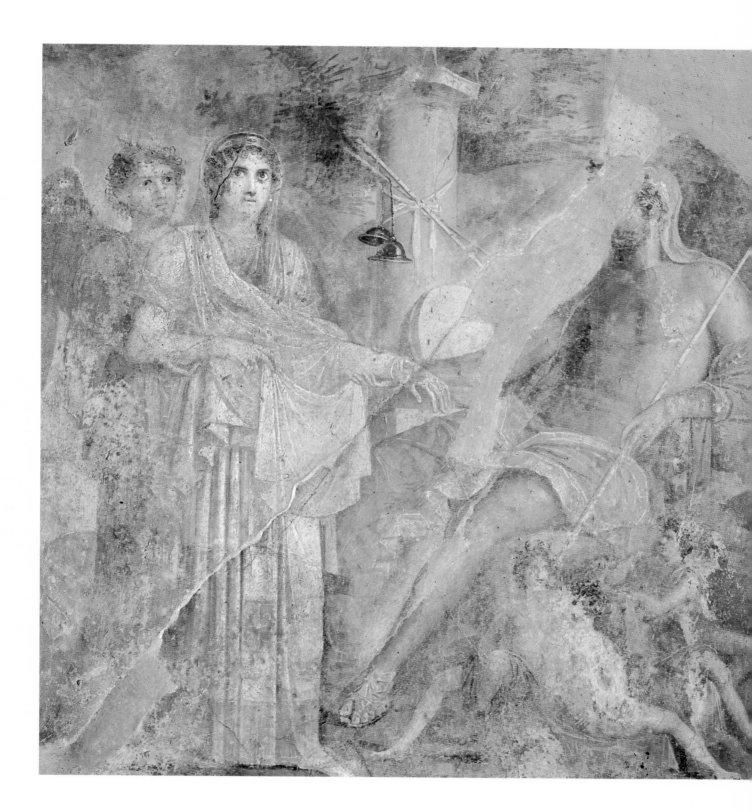

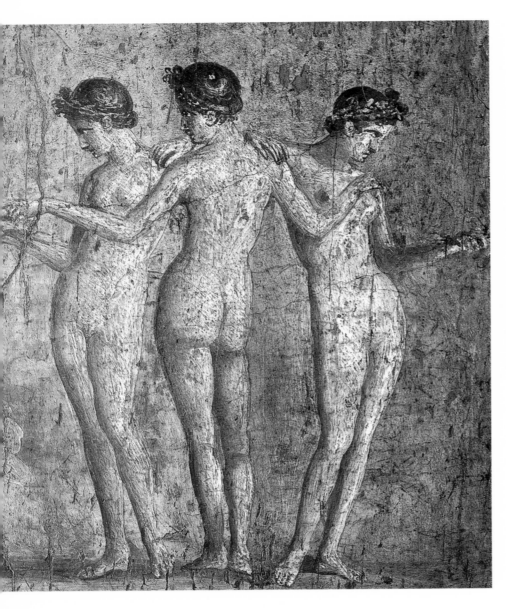

The Charites
MANN inv. no. 9231
Pompeii VI.17.Ins. Occ., 31

Originally, there were only two Charites (or Graces), daughters of Zeus and Eurynome. According to Hesiod, the Greek man of letters who lived at the beginning of the seventh century B.C., they then become three, taking the names Euphrosyne, Aglaea, and Thalia. Symbolizing beauty, grace, and wisdom, the Charites came to be represented embracing each other, nude and with flowers, fruit, and ears of wheat in their hands. This iconographic scheme was repeated extensively in painting, mosaic, and sculpture of the Hellenistic period.

Europa on the Bull

*MANN inv. no. 111475.
Pompeii IX.5.18, Casa di
Giasone, cubiculum g, West
wall;
Third Style*

Zeus, being in love with Europa, the daughter of Agenor, transformed himself into a white bull. He then mingled in a herd of cattle led by Hermes near the seashore where Europa and her companions usually gathered flowers. Europa was struck by the beauty of the white bull. After playing with him and hanging wreaths of flowers on his horns, she leapt on his back, making him trot down to the shore of the sea. The bull threw himself into the waves and carried Europa to Crete. There, she bore Zeus three sons, among them Minos. This composition, probably derived from a heavily reworked Hellenistic painted original, shows the moment before the abduction: Europa rides on the bull's back while three of her companions approach to caress him.

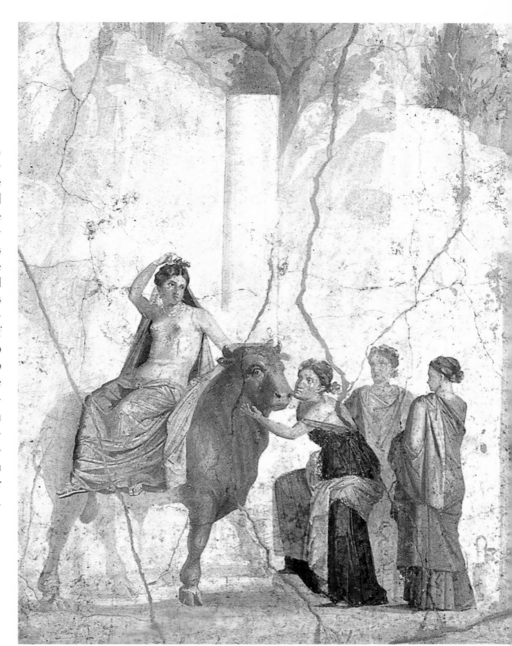

Leda with the Swan

Pompeii VI.16.7, Casa degli Amorini Dorati,
cubiculum r, West wall;
Fourth Style

The scene, set in an interior and known in several replicas, refers to the famous transformation of Zeus into a swan to win over Leda, the wife of King Tyndareus of Sparta. Afterward, Leda laid an egg from which emerged Helen of Troy and the twins Castor and Pollux. As a result of this miraculous event, Leda was deified with the name of Nemesis.

Io, Argos, Hermes

MANN inv. no. 9557
Pompeii I.4.5, Casa del Citarista,
triclinium no. 37, North wall;
Fourth Style

Zeus, in an attempt to protect his new lover Io from the wrath of Hera, transformed Io into a heifer. Hera objected to his ownership and entrusted the beautiful white cow to Argos Panoptes, the monster with a hundred eyes, to keep Io far from Zeus's lustful advances. Zeus sent Hermes to liberate Io. The messenger god lulled Argos to sleep with the sound of his flute, then decapitated the monster and freed Io. The version in the *Casa del Citarista* is more complete than other paintings in the Vesuvian area, which depict only Io and Argos. This one refers directly to a painting with the same subject found in the *Casa di Livia* on the Palatine at Rome. The painting, with the monstrous guardian humanized at least in his essential features, probably derives from a work by Nicias, a painter active primarily in the last thirty years of the fourth century B.C. Nicias's painting was brought to Rome and displayed in the Porticoes of Pompey.

Ares and Aphrodite
Pompeii V.4.a, Casa di M. Lucretius Fronto,
tablinum no. 7, North wall;
Third Style

Ares and Aphrodite
MANN inv. no. 9248
Pompeii VII.9.47, Casa delle Nozze
di Ercole, tablinum no. 7, West wall;
Fourth Style

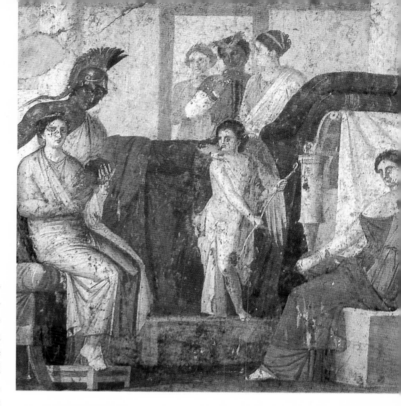

Hephaestus, the god of fire and metalwork, had married Aphrodite, who was secretly in love with Ares. Helios, the sun god, discovered Aphrodite's betrayal. Rising into the sky, he saw the two lovers in an alcove in Ares' Thracian palace and informed Hephaestus of the deception. In order to expose them, Hephaestus forged a metal net in his smithy and placed it in the alcove. When the two lovers encountered each other again, the net fell, imprisoning them while they were in the midst of tender shows of affection. The furious Hephaestus exhibited the trapped lovers to all the gods. In addition, he demanded from his father-in-law, Zeus, restitution of the wedding gifts as a condition of granting Aphrodite and Ares their liberty. The fascinating theme of the love of Ares and Aphrodite was depicted often in Pompeian painting, repeating two compositional schemes whose most significant examples, reproduced here, are in the *Casa di M. Lucretius Fronto* and the *Casa delle Nozze di Ercole*. The first composition is set in the alcove of the palace of Ares at the moment that Helios, the central winged figure, discovers the two lovers. In the second composition, in contrast, the meeting between the two lovers takes place in an undefined spatial frame, while Erotes entertain themselves, playing with the arms of Ares. The entire scene is enveloped in a suffused romanticism, with the figures almost transformed into common mortals engaged in an amorous encounter. This is demonstrated in particular by their facial features, which are perhaps closer to portraits than to idealized faces.

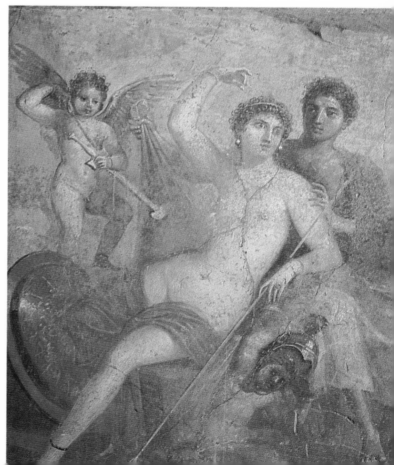

Hermaphroditus

Pompeii IX.8.3, Casa del Centenario, triclinium no. 41, East wall; Third Style

After Aphrodite had been liberated from the net imprisoning her with her lover Ares (thanks to the intercession of all the gods, especially Poseidon), she turned her attentions to Hermes. Aphrodite conceived a child with him named Hermaphroditus, from the union of the names of the two gods. He was raised by

the nymphs of Mount Ida. When he reached adolescence, Hermaphroditus began a long voyage that carried him to Asia Minor. There, he stopped along the banks of a lake inhabited by the nymph Salmacis. Struck by the beauty of the youth, the nymph fell in love with Hermaphroditus. But he was indifferent and refused her offerings. Nevertheless, Salmacis did not give up. When Hermaphroditus dove into the lake to bathe, she approached him, invoking the gods that their bodies would never separate. Faced with a wish so fervent, the gods agreed, creating a being half male and half female.

Priapus

Pompeii VI.15.2, Casa dei Vettii, entrance b, West wall; Fourth Style

After her infatuations with Ares and Hermes, Aphrodite also gave in to the flattery of Dionysus, with whom she conceived Priapus. The child was born with enormous genitalia through the action of Hera, who disapproved of Aphrodite's libertine conduct. The cult of Priapus at Lampsacus in Mysia, his place of origin, spread to the entire romanized world. During this process of expansion, it mingled with the cult of Pan and with the phallic rites of the Dionysiac festivals. In this painting, the god, who looks Eastern because of his Phrygian cap and thick beard, rests his large phallus on one of the plates of a scale. The other plate holds a purse full of money, clearly an auspicious reference bearing good luck for the inhabitants of the house. In addition to images of Priapus, Pompeii and Herculaneum display an extremely diverse range of phallic representations; they signify generative force, abundance, and happiness.

THEREFORE HAIL, O SACRED PRIAPUS, HAIL. JOVE HIMSELF, THROUGH YOUR WILL, SET ASIDE HIS LIGHTNING AND, DRIVEN BY DESIRE, LEFT HIS BEAUTIFUL ABODES

CARMINA PRIAPEA

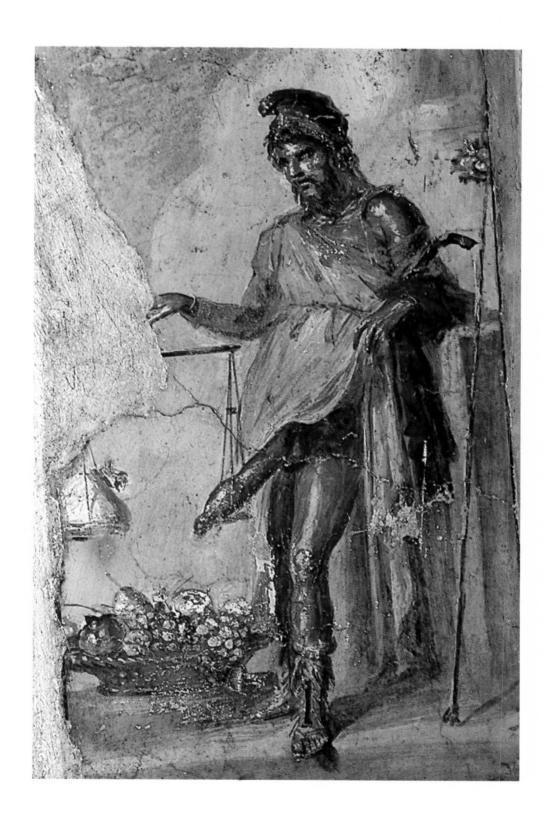

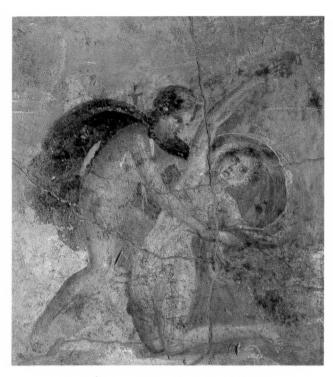

Apollo and Daphne

MANN inv. no. 9536
Pompeii IX.3.5, Casa di M. Lucretius,
triclinium no. 21, South wall;
Fourth Style

Apollo tried to seduce the nymph Daphne, daughter of the river god Peneius in Thessaly. The fleeing nymph invoked Mother Earth for help and was transported to Crete. In Daphne's place, Mother Earth made a laurel plant grow, whose leaves Apollo. to console himself, wove into a wreath. The episode of the attempted seduction of Daphne appears as an artistic composition from the Hellenistic period onward. The subject is particularly widespread among wall paintings in the Vesuvian cities.

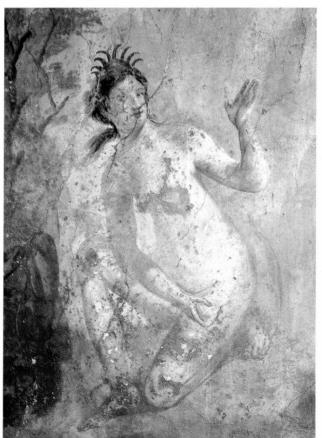

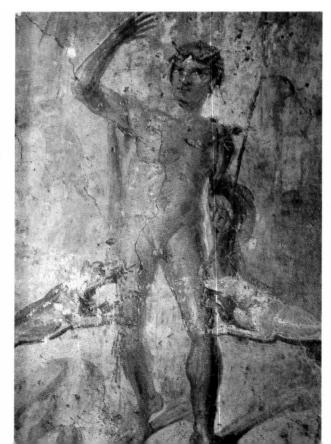

Artemis and Actaeon

Pompeii II.2.2, Casa di D. Octavius Quartio,
portico i, West wall;
Fourth Style

While she was still a child, Artemis, goddess of the hunt and sister of Apollo, asked to remain eternally a virgin. Her father, Zeus, granted her wish. One day, Actaeon, the son of Aristaeus, discovered Artemis bathing naked in a river. Struck by her beauty, he remained for a long time watching her. Later he imprudently boasted to his friends that the goddess, pleased, had let him see her nude. Infuriated by Actaeon's insolence, Artemis transformed him into a stag and had him ripped apart by a pack of dogs. At Pompeii, three large compositions with this theme are preserved on the walls of houses bordering open spaces. In two cases (*Casa di D. Octavius Quartio* and *Casa di Sallustio*), the scene appears as the background of a pergola and garden; and in the third example (*Casa del Menandro*), it appears on the interior of exedra no. 22 of the peristyle.

Thetis and Hephaestus

MANN inv. no. 9529
Pompeii IX.1.7, triclinium e, North wall;
Fourth Style

Hera threw her son Hephaestus from Olympus into the sea because he was weak and ugly. He was saved and taken in by Thetis and Eurynome. To reward his saviors, Hephaestus set up a metalworking shop in an underwater cave, where he produced all sorts of objects. This composition from Pompeii, among the most complex of those found, depicts Hephaestus and his assistants in the act of forging the precious arms that Thetis will give to her son Achilles, and which Achilles will wear to vindicate the death of Patroclus. Particularly interesting in this painting is the way Thetis's image is reflected in the shield that the seated Hephaestus and his assistant are showing the goddess.

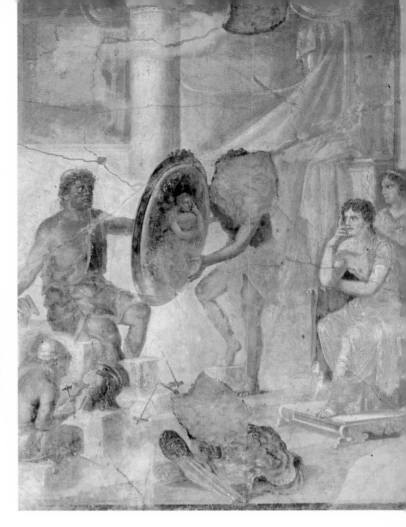

CONCEDE ME, I BESEECH YOU, ETERNAL
VIRGINITY; AS MANY NAMES AS MY BROTHER
APOLLO; A BOW AND ARROWS LIKE HIS; THE TASK
OF BEARING LIGHT
CALLIMACHUS, *HYMN TO ARTEMIS*

Death of Pentheus

Pompeii VI.15.1, Casa dei Vettii, triclinium n., East wall; Fourth Style

Dionysus, son of Zeus and the inventor of wine, was driven mad by the jealous Hera, who sought vengeance for her husband's many betrayals. Dionysus wandered through the world accompanied by Silenus, his tutor, and by a group of Satyrs and Maenads. They were armed with swords and snakes and with staffs called *thyrsoi*, which were covered with ivy and topped with a pinecone. In his wanderings, Dionysus returned to Europe, where, thanks to his grandmother Rhea, he was initiated into the Mysteries and puri-fied of all of his madness-induced misdeeds. Later, he arrived at Thebes in Boeotia, where he attempted to introduce his cult by inviting the women of the city to unite at a nocturnal festival on Mount Cithaeron. The king of Thebes, Pentheus, was opposed to this initiative and sought to imprison Dionysus together with the Maenads. Instead of capturing Dionysus, Pentheus captured a bull. Pentheus went to Mount Cithaeron, where he was discovered by the Maenads who, possessed by the mystic frenzy, tore him to pieces.

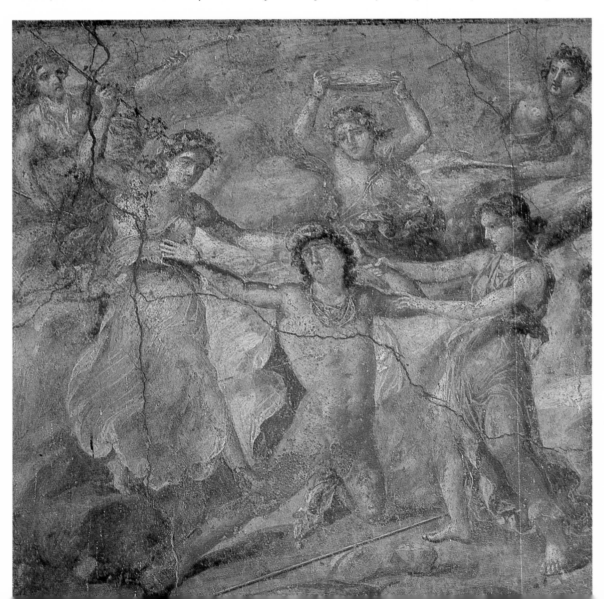

Dionysus and Ariadne

MANN inv. no. 9286

Pompeii I.4.5, Casa del Citarista, exhedra no. 35, South wall; Fourth Style

Following the bloody death of Pentheus, all of Boeotia accepted the cult of Dionysus. Therefore the god set off for the islands of the Aegean. At Naxos, he encountered and married King Minos's daughter Ariadne. She had been abandoned by Theseus, in accordance with Athena's command, after Theseus killed the Minotaur. This painting in the *Casa del Citarista*, derived from a Hellenistic original of the second half of the third century B.C., is considered the best replica of this theme. Dionysus is surprised by the sight of Ariadne with her head in the lap of Hypnos (god of sleep); Eros lifts Ariadne's mantle to reveal her to the god and his retinue.

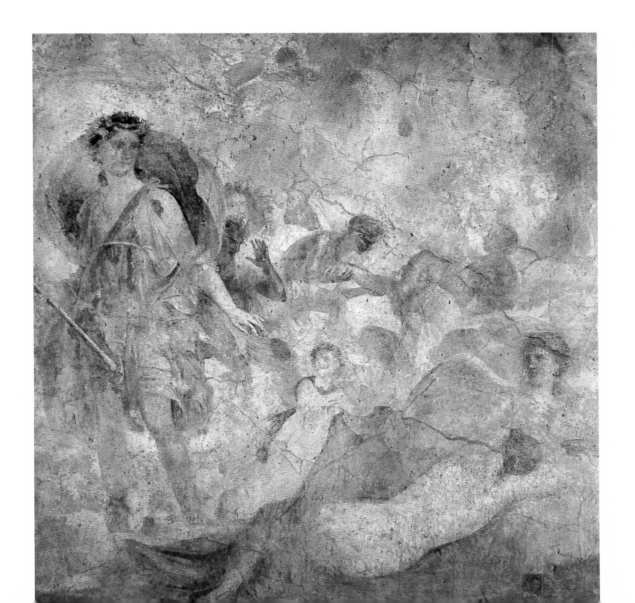

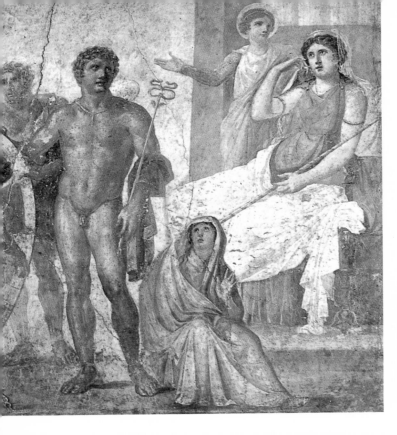

Punishment of Ixion

Pompeii VI.15.1, Casa dei Vettii,
triclinium p, East wall;
Fourth Style

Ixion, the king of the Lapiths, promised to marry Dia, the daughter of Ioneus. But, in order to avoid consigning the rich wedding gifts that he had promised, Ixion killed his father-in-law. Zeus, mindful of his own continual betrayals, showed himself to be understanding of Ixion's behavior and agreed to purify the king. Afterward, Zeus invited Ixion to his table. In Olympus, Ixion planned to seduce Hera, thinking that she would yield to his proposals to take revenge for the numerous infidelities of her husband. Zeus guessed what he was plotting and gave a cloud the form of Hera. Ixion united with the cloud, begetting the Centaur. Having exposed the betrayal, Zeus immediately fell on Ixion. Zeus had him whipped by Hermes until he had uttered the words: "The benefactors must be honored"; then, Ixion was tied to a burning wheel, condemned to spin in the sky forever. The myth's final phase is depicted in this painting, in which Ixion is already tied to the wheel. Hermes stands at the center; Hera is seated majestically on the right, with Iris at her side.

Selene and Endymion

MANN inv. no. 9245
Herculaneum, provenance unknown

Selene saw Endymion, the son of Zeus and the nymph Calica, while he lay resting in a cave. Struck by his beauty, she lay down by his side and sweetly kissed his closed eyes. Later, Endymion returned to the same cave and fell into a sleep from which he never awoke. He remained eternally young, thus satisfying Selene's desire: she wished to kiss his sleeping body without being swept away by the passion of love. Endymion was frequently depicted in small paintings in the Vesuvian area, usually as a sleeping hunter with two lances and a dog at his side, being visited by Selene. These representations followed an iconographic scheme that was probably Hellenistic in origin.

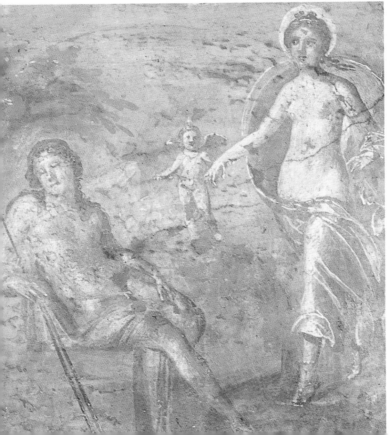

Polyphemus and Galatea

MANN inv. no. 27687
Pompeii VII.4.48, Casa della Caccia Antica,
oecus no. 15, South wall;
Fourth Style

According to an episode related by Philoxenus of Cythera, the Cyclops Polyphemus loved the Nereid Galatea, protectress of flocks. She betrayed him, preferring the handsome Acis. The jealous Cyclops heaved a rock at Acis, killing the youth, who was then transformed into a river. In addition to this composition, in which Polyphemus and Galatea are locked in a tight embrace, another painting in the Vesuvian area shows the Cyclops seated on a rock by the sea, from which he watches Galatea pass by on a dolphin, accompanied by other Nereids.

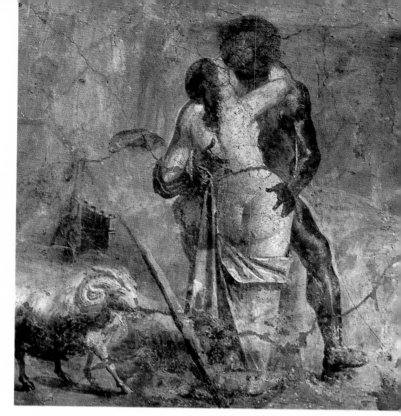

Alcestis and Admetus

MANN inv. no. 9027
Pompeii VI.8.3, Casa del Poeta Tragico (?)

Pelias, in order to chose a bridegroom from among his daughter Alcestis's numerous suitors, decided that he would concede her only to a man capable of yoking a lion and a wild boar to a chariot. Admetus, the king of Pherae, succeeded in both overcoming the difficult trial and marrying Alcestis, thanks to the intercession of his protector Apollo. In addition, Apollo was also able to arrange with Artemis that Admetus could avoid his own death if a member of his family would die in his stead. When the fatal moment arrived, Admetus despaired and tried to convince his parents to renounce their lives for his. Only his wife, Alcestis, performed this supreme act of love; she poisoned herself and thus allowed Admetus to survive. This painting depicts the reading of the oracle. Alcestis and Admetus are on the left, the dominant figure of Apollo stands in the center, and Admetus's aged parents watch from the right.

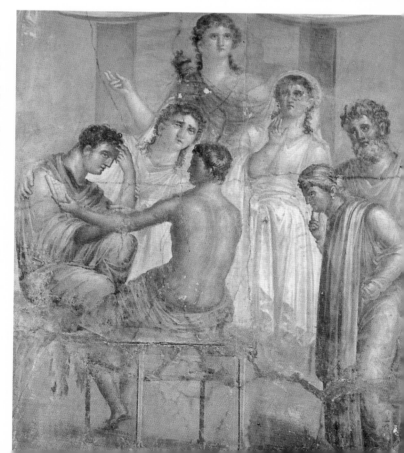

Phrixus and Helle

MANN inv. no. 8889
Pompeii, VI.17.Ins. Occ.;
Third Style

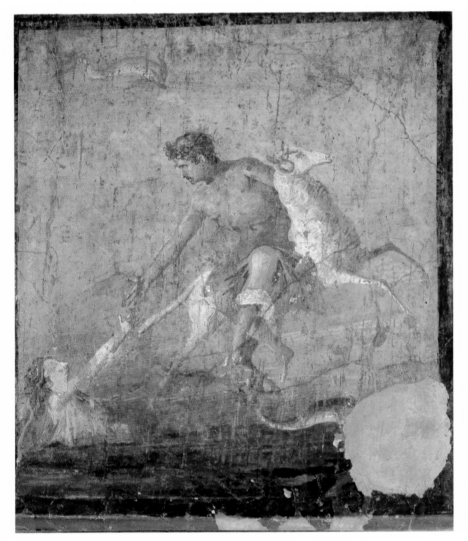

Athamas, by order of Hera, married Nephele by whom he had two sons, Phrixus and Leucon and a daughter Helle. When Nephele was betrayed by Athamas with Ino, Hera promised that she could take immediate revenge against her husband. Strengthened by Hera's vow, Nephele asked the men of Boeotia to kill her husband; however, they did not listen to her. Meanwhile, Ino sought revenge on her rival Nephele by convincing the women of Boeotia to dry the seeds of wheat, thereby compromising the next year's harvest. Continuing her diabolical plan, Ino succeeded in corrupting the messengers Athamas had sent to the Delphic oracle for advice: they falsely responded that the land would become fertile again only if Nephele's son Phrixus were sacrificed. A desperate Athamas led Phrixus to Mount Laphystius and was about to cut his throat when a winged ram with a golden fleece appeared, sent by Hera. The ram exhorted the youth to save himself, and Phrixus immediately leapt on the ram's back. He was joined by his sister, Helle, who did not want to abandon her brother. During the voyage, Helle was struck by vertigo and fell into the sea in the strait between Europe and Asia; in her honor, the strait was called the Hellespont. Phrixus arrived safely in Colchis, where he sacrificed the ram to Zeus, preserving the golden fleece. This rare representation of the myth of Phrixus and Helle is particularly compelling because of the parallels with the well-known Biblical story of the sacrifice of Isaac.

Danaë and Perseus
MANN inv. no.111212
Pompeii V.1.18, Casa degli Epigrammi, exhedra o,
West wall; Fourth Style

To avoid an oracle's prediction that he would be killed by
his grandson, Acrisius imprisoned his only daughter,
Danaë, in a tower guarded by a band of ferocious dogs.
Zeus, however, descended on Danaë in the form of a show-
er of gold, begetting a baby who was named Perseus. When
Acrisius found out, he could not bring himself to kill Danaë
and the newborn; instead, he enclosed them in a wooden
ark that was thrown into the sea. Danaë and Perseus were
saved when the ark was found by a fisherman near the is-
land of Seriphus. Based on a passage in Pliny the Elder's
Natural History (35.139), this composition possibly de-
rives from a cartoon of a painting by Artemon, who was ac-
tive in the first half of the third century B.C.

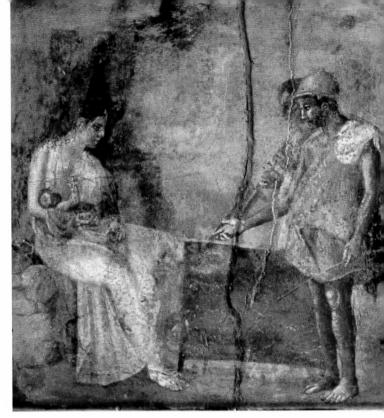

Perseus and Andromeda
MANN inv. no. 8998
Pompeii VI.9.6, Casa dei Dioscuri,
peristyle no. 53, SE pilaster;
Fourth Style

Cassiopea, wife of the Ethiopian king Cepheus, boasted
insolently in public that both she and her daughter
Andromeda were superior in beauty to the Nereids
themselves. The offended sea nymphs invoked the help of
Poseidon, who let loose a sea monster against the coast of
the Ethiopian kingdom. King Cepheus consulted an oracle
to find out how to save his subjects; he was instructed to
sacrifice Andromeda to the monster. Just as Cepheus was
tying Andromeda to a rock, the hero Perseus—returning
from the victorious exploit of decapitating the Gorgon
Medusa—flew overhead and saw the beautiful girl. After he
had obtained the hand of Andromeda from her parents,
Perseus saved her by tricking and then decapitating the
marine monster; Perseus's weapon was a sickle donated by
Hermes. The fascinating story of Andromeda's liberation
appears in numerous painted replicas, probably derived
from a painting by Nicias (active in the fourth century B.C.)
that was displayed in Rome in the Porticoes of Pompey.

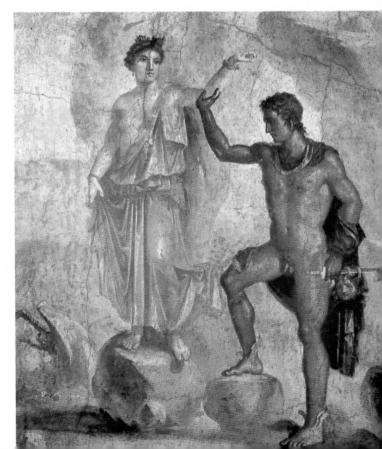

Bellerophon and Pegasus

SAP inv. no. 20878
Pompeii I.8.8, thermopolium, triclinium *no. 10*,
West wall; Third Style

Before attempting to kill the Chimaera (the monster with the head of a lion, body of a goat, and tail of a snake), Bellerophon consulted an oracle that counseled him to capture Pegasus, the winged horse favored by the Muses. The hero succeeded in taming the horse near the fountain of Pirene on the Acropolis, thanks to the help of the golden bridle given to him by Athena, who appears in the right of this painting.

Punishment of Dirce

Pompeii VI.15.1, Casa dei Vettii, triclinium *n.*,
South wall; Fourth Style

Antiope was seduced by Zeus and bore two sons: Amphion and Zethus. In revenge, her husband, Lycus, abandoned the twins on Mount Cithaeron. Because of her infidelity, Antiope was subjected to continual abuse and oppression, especially from her aunt, Dirce. One day, Antiope fled; she sought refuge in a hut where her two sons, who had been saved on Mount

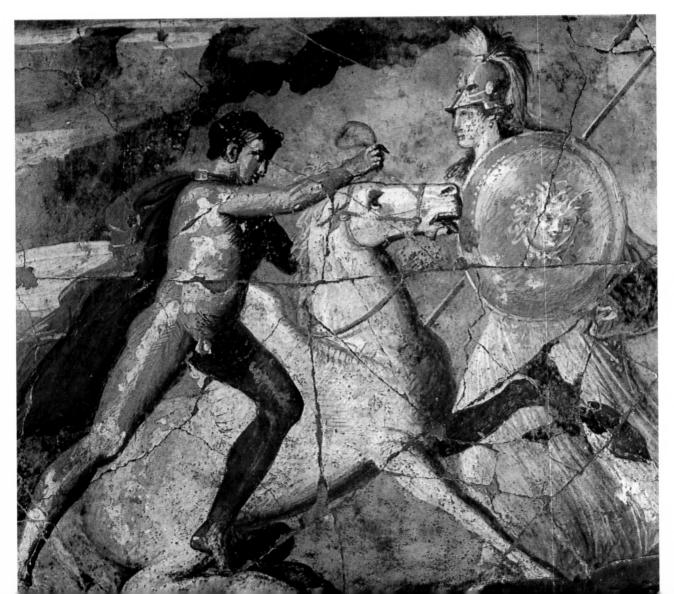

Cithaeron and raised by a herdsman, now lived. Mistaking Antiope for a fugitive slave, the twins refused to give her asylum, thus permitting Dirce to capture her again. The herdsman, however, revealed her true identity to the two boys. Amphion and Zethus rushed to save their mother, then took revenge on Dirce by tying her hair to a bull, which killed her. The compositional scheme of this painting, representing the moment immediately preceding Dirce's punishment, is believed to derive from a sculptural group from the Hellenistic period.

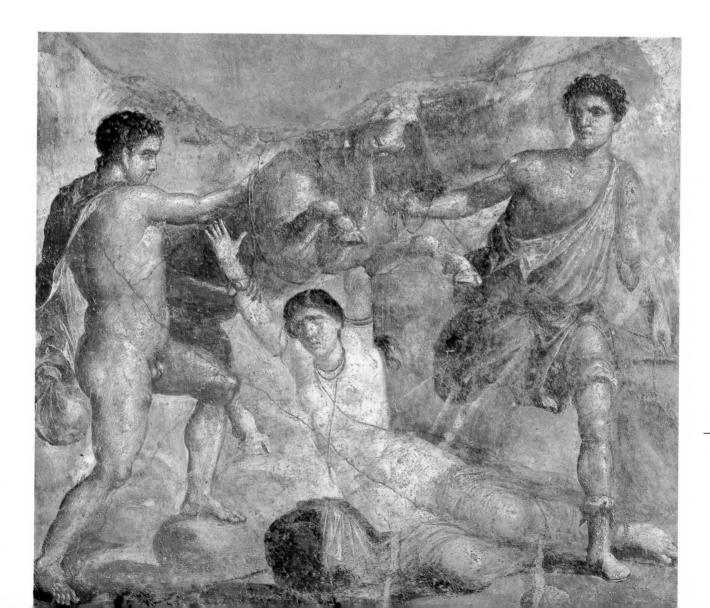

Massacre of the Niobids

MANN inv. no.111479
Pompeii VII.15.2, Casa del Marinaio, exhedra z', North wall;
Third Style

Niobe, wife of Amphion of Thebes, was so proud of her seven sons and seven daughters that she dared to publicly disparage the goddess Leto for having only two children, Apollo and Artemis.

Manto, daughter of the blind seer Teiresias, advised the Theban women to perform a sacrifice in order to placate Leto, who was offended by the queen's continual insolence. Infuriated by this reparative action organized without her knowledge, Niobe interrupted the ceremony. Leto then decided to relentlessly punish the presumptuous mortal, sending Apollo to kill Niobe's male children while they were hunting on Mount Cithaeron, and Artemis to kill the girls while they were weaving in the palace. This Pompeian composition, which is probably of Hellenistic derivation, depicts with immediacy and vivacity the massacre of Niobe's sons, who are shown here engaged in the hunt.

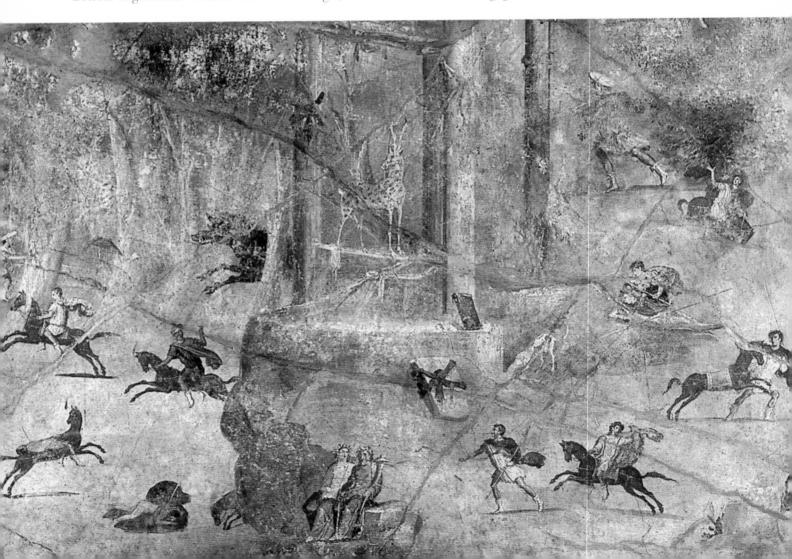

Meleager and Atalanta
MANN inv. no. 8990
Pompeii VI.9.3, Casa del Centauro,
tablinum no. 26, North wall; Third Style

When Oeneus, king of Calydon in Aetolia, did not include Artemis in the annual sacrifice to the twelve gods of Olympus, the offended goddess sent a violent wild boar to devastate the fields and kill the livestock. Oeneus then invited the best warriors in Greece to hunt the dangerous wild boar. His son Meleager and the beautiful Atalanta, daughter of Iasus, joined the pursuit. In the course of the bloody hunt, the boar was first wounded by Atalanta and then killed by Meleager. This composition captures the moment just after the violent action: Mealeager is seated, with the boar's body at his feet. The interplay of unspoken glances underscores Meleager's strong attraction toward Atalanta, who later caused his death.

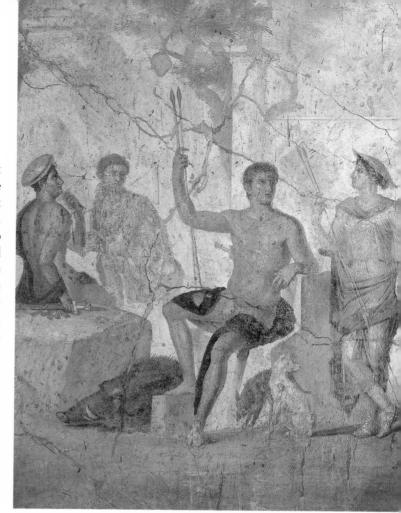

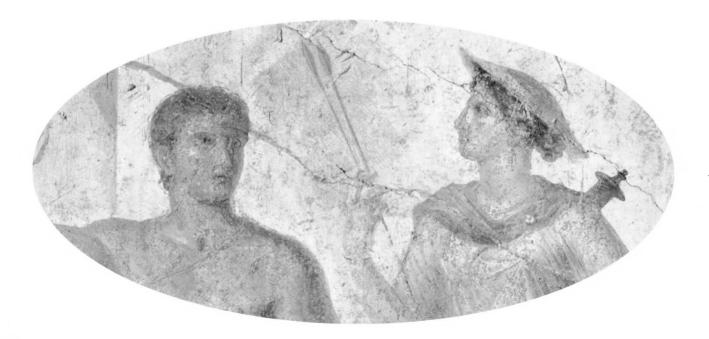

Narcissus

Pompeii V.4.a, Casa di M. Lucretius Fronto,
cubiculum *no. 6, North wall;*
Fourth Style

By the time he was an adolescent, Narcissus, the extremely handsome son of the nymph Liriope and the river god Cephissus, had already rejected many suitors of both sexes, including the inconsolable nymph Echo. Aminius, Naracissus's most ardent suitor, killed himself over the indifferent youth, crying out in pain and invoking the gods as he died. Artemis decided to punish Narcissus for his cruel behavior. She caused Narcissus to approach a limpid mirror of water where he saw an extremely beautiful image of a youth whom he tried in every way to embrace and kiss. Having recognized himself, Narcissus remained for hours, spellbound, to stare at his own reflection. The pain of not being able to satisfy his passion and the simultaneous pleasure in

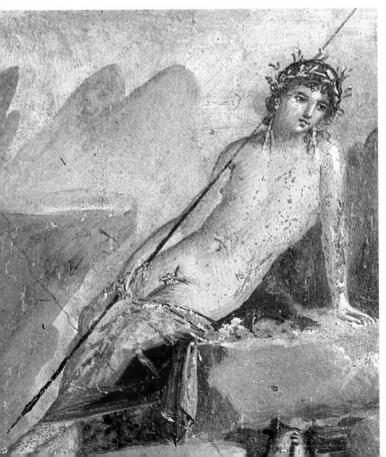

his torment led him to desperation. He ran a sword through his chest, exclaiming, "O youth loved in vain, good-bye!"

Daedalus and Pasiphae

Pompeii VI.15.1, Casa dei Vettii,
triclinium *p, North wall;*
Fourth Style

Minos, king of Crete, had married Pasiphae. It was customary to annually sacrifice a bull to Poseidon, god of the sea, but one year King Minos tried to trick the god by sacrificing a less-important animal. In revenge, Poseidon made Pasiphae fall in love with the white bull withdrawn from the sacrifice. Pasiphae confided her strange and sudden passion to the famous craftsman Daedalus. To help Pasiphae, Daedalus constructed a wooden cow; it was covered with hides and mounted on four wheels hidden in its hooves. Pasiphae entered the replica through a sliding door. She had it carried to the field where the bull usually grazed. The beautiful white bull quickly noticed the cow, approached, and mounted her. Through this ingenious trick, Pasiphae satisfied her peculiar desire—and begot the Minotaur, the monster with the head of a bull and a human body. In this painting, Daedalus shows the cow to Pasiphae; the scene takes place in the craftman's workshop, as the image of the attendant busily at work demonstrates clearly.

> BUT NARCISSUS HAD VANISHED AND ECHO SPENT THE REST OF HER LIFE IN SOLITARY VALLEYS, WAILING OF LOVE AND REGRET, UNTIL OF HER, ONLY THE VOICE REMAINED.
>
> OVID, *METAMORPHOSES*

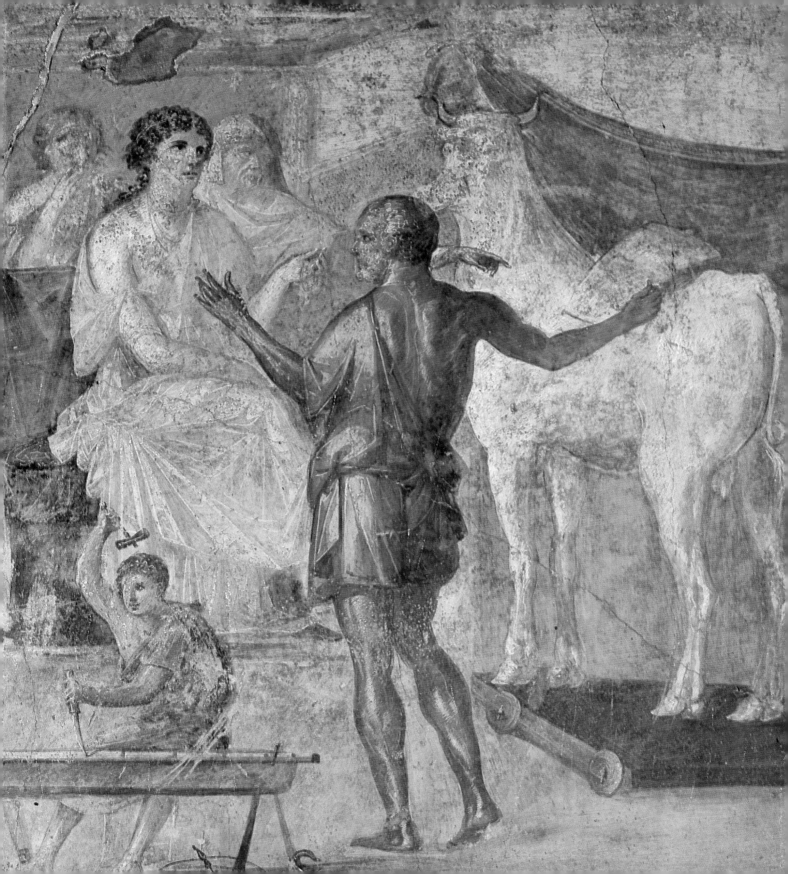

Fall of Icarus
MANN inv. no. 9506
Pompeii, provenance unknown

When Minos discovered that Daedalus had helped Pasiphae mate with the white bull (see previous entry), the king imprisioned Daedalus and his son Icarus in the Labyrinth where the Minotaur lived. Pasiphae, however, grateful for the help received, freed both of them. In order to escape, Daedalus constructed for himself and his son a pair of wings whose feathers were interwoven and joined with wax. Before taking flight, Daedalus warned Icarus not to fly too close to the sun (because the wax would melt) nor too close to the sea (lest the feathers become damp). During the journey, however, Icarus, exalted by flying, flew ever closer to the sun—so close that the wax melted. Falling into the sea, he drowned. Paintings like this one, in which Icarus has already fallen, are thought to be of Hellenistic origin. In contrast, Pompeian compositions in which Icarus is depicted as he is about to fall to earth, with a city in the background, are believed to represent new creations of the Roman period.

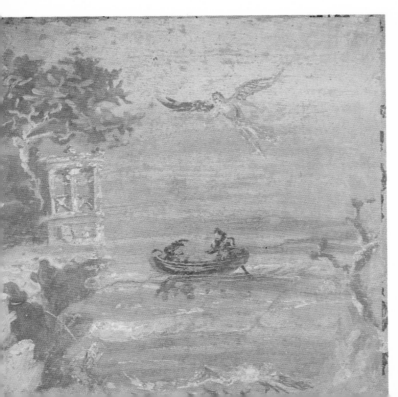

Theseus the Liberator
MANN inv. no. 9043
Pompeii VII.2.16, Casa di M. Gavius Rufus,
exhedra o, East wall; Fourth Style

Following the murder of his son Androgeos, King Minos of Crete imposed a tribute on the Athenians: every nine years, fourteen children—seven youths and seven maidens—must be fed to the Minotaur, the half-bull, half-human son of Pasiphae and a white bull. On the day the sacrificial children were to depart for Crete, the famous hero Theseus was at Athens. In order to liberate the city from this bloody tribute, Theseus took the place of one of the Athenians. In Crete, Ariadne, daughter of Minos and Pasiphae, noticed Theseus, evidently due to Aphrodite's influence. Ariadne fell so madly in love with Theseus that she offered to help him kill her monstrous half-brother. In exchange, she made Theseus promise to take her to Athens and marry her. Ariadne gave Theseus a ball of magic thread to tie to the doorpost; by following it he could enter and leave the Labyrinth without becoming hopelessly lost. After killing the sleeping Minotaur, Theseus exited the Labyrinth, arrived at the harbor, and succeeded in setting sail, together with the Athenian children and Ariadne, whom he later abandoned at Naxos before arriving at Athens.

The original painting of Theseus the Liberator dates to the first half of the third century B.C. Several subsequent replicas exist; the best is considered to be the fresco from the Basilica of Herculaneum, in which the figure of Theseus echoes classical Lysippan statuary. In contrast, the painting shown here, from the *Casa di M. Gavius Rufus*, presents numerous inconsistencies and imperfections in the bodies' anatomical details and foreshortening. Nevertheless, the hero's face is noteworthy for displaying characteristics generally considered to be typically Campanian.

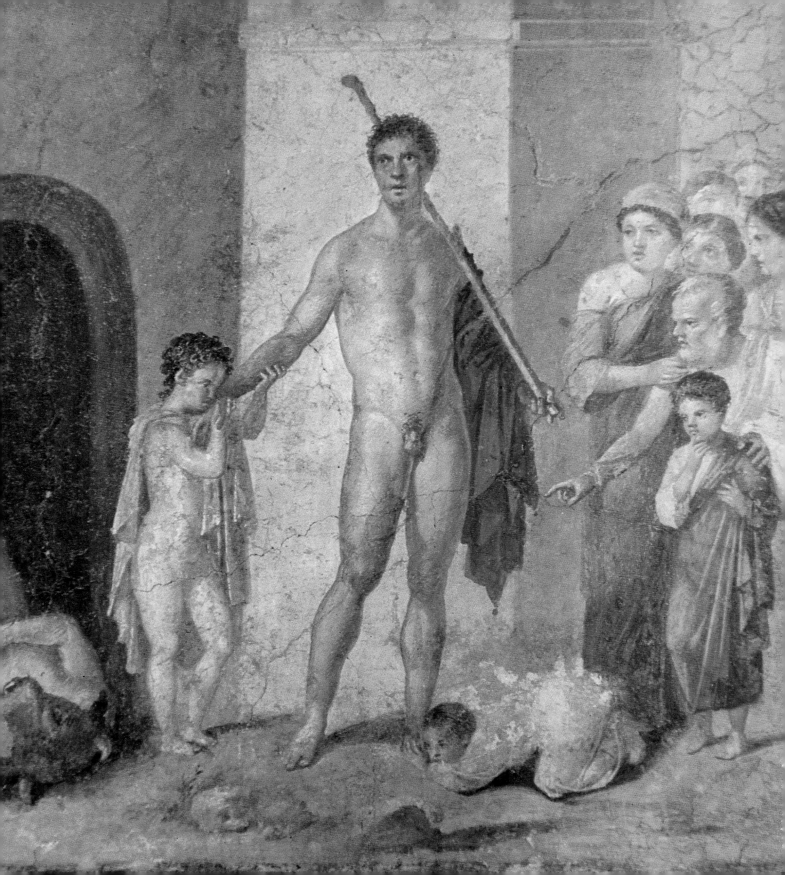

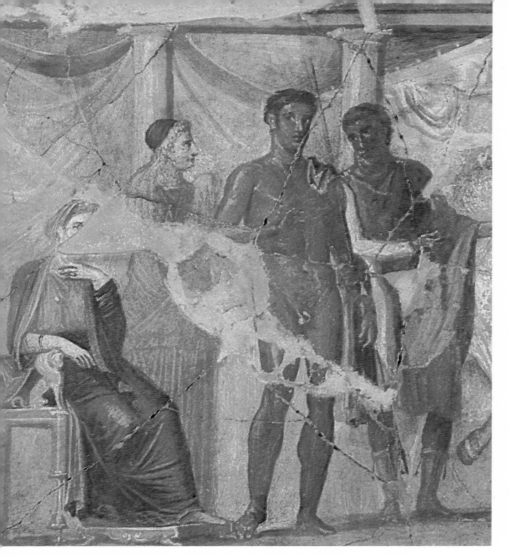

Phaedra and Hippolitus
SAP inv. no. 20620
Pompeii, provenance unknown

After Theseus married Phaedra, sister of the unfortunate Ariadne, he sought to avoid possible claims to the throne of Athens that was to go to his brothers, so he sent Hippolytus to Troezen. Hippolytus was Theseus's son by his illegitimate wife Antiope, queen of the Amazons. Phaedra, however, being secretly in love with Hippolytus, followed her stepson to Troezen, where she admired him every day as he exercised in the nude. One day, following the advice of an elderly wet nurse, Phaedra wrote a letter to Hippolytus revealing her secret passion and inviting him to participate with her in a hunt. Hippolytus was shocked by the revelation. After he had burned the letter, he rushed into Phaedra's bedroom, reproving her for her mad desire. Devastated by the rejection, Phaedra ran out of the room screaming that she had been raped. She hung herself from a beam, leaving a note in which she accused Hippolytus of the vile action. Various aspects of the myth of Hippolytus appear in the Vesuvian area, including the episode of the advice of the wet nurse as well as compositions uniting several consecutive events. This panel shows Phaedra seated, with the wet nurse in attendance and Hippolytus ready to leave for the hunt. It probably derives from a painted original from the early Hellenistic period.

WHY DON'T WE GO TO LIVE TOGETHER, FOR SOME TIME AT LEAST, USING THE HUNT AS A PRETEXT? NO ONE WILL SUSPECT OUR TRUE SENTIMENTS. ALREADY WE LIVE UNDER THE SAME ROOF AND OUR AFFECTION WILL BE CONSIDERED INNOCENT OR EVEN PRAISEWORTHY.

OVID, *HEROIDES*

Pirithous and the Centaurs

MANN inv. no. 9044
Pompeii VII.2.16, Casa di M. Gavius Rufus, exhedra o, West wall; Fourth Style

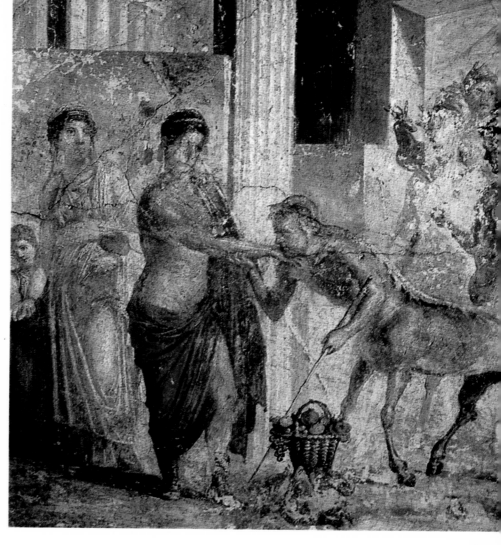

When Peirithous, king of the Lapiths, married Hippodameia, he invited all the gods of Olympus to the wedding banquet—except Ares and Eris. He was aware of the problems Eris generated at the wedding of Peleus and Thetis, where, by throwing the famous golden apple inscribed "to the most beautiful," he set in motion a chain of events leading to the terrible Trojan war. All of the guests could not fit in the palace, so the Centaurs (cousins of Peirithous) and numerous princes of Thessaly were accommodated in a vast grotto. Unaccustomed to wine, the Centaurs were seduced by its aroma and drank it without diluting it with water. They became so drunk that when the bride entered the grotto to greet the guests the Centaur Eurythus seized her and carried her away by her hair. The other Centaurs followed his example, trying to rape women and boys. A furious battle ensued, abetted by Ares and Eris, who manipulated the actions of the guests as revenge for not having been invited. The fighting lasted until the evening and gave rise to the eternal hostility between the Lapiths and the Centaurs. This painting depicts the preamble to the violent episode, with the Centaurs presenting themselves to Peirithous by bowing and offering gifts within the royal palace.

Orestes and Pylades

MANN inv. no. 9111
Pompeii I.4.5, Casa del Citarista, exhedra no.
35, East wall; Fourth Style

Orestes was pursued by the three goddesses of revenge, the Erinyes (called Furies by the Romans), because he had killed his mother and her lover to avenge the death of his father. As expiation, Pythia, priestess of Apollo, ordered Orestes to go to Tauris and bring a particularly venerated ancient wooden statue of Artemis back to Attica. Orestes went to Chersonesos in Tauris with his inseparable friend Pylades, where the idol was conserved in a temple whose priestess, unbeknownst to Orestes, was Iphigenia, his own sister. (Iphigenia had been saved by Artemis herself: the goddess had enveloped Iphigenia in a cloud and withdrawn her from the sacrifice at the harbor of Aulis, leaving a hind in her place and thus permitting the Greek fleet to depart for the conquest of Troy.) However, Orestes and Pylades were discovered and captured, and King Toantes ordered that they be sacrificed by the priestess. During the preparations for the rite, Orestes and Iphigenia recognized each other—to their great surprise. To avoid sacrificing her brother and his friend, Iphigenia explained to Toantes that because of their earlier serious misdeeds, the prisoners had to be purified on the seashore in the presence of the goddess's image. Toantes fell into the trap and agreed to the rite of purification. Iphigenia, Orestes, and Pylades thus managed to escape on a ship, carrying with them the statue of the goddess.

This composition, probably derived from an original attributed to Timomachos, who lived in the fourth or first century B.C., shows Iphigenia emerging from the temple. The prisoners, Orestes and Pylades, stand on the left; on the right sits King Toantes.

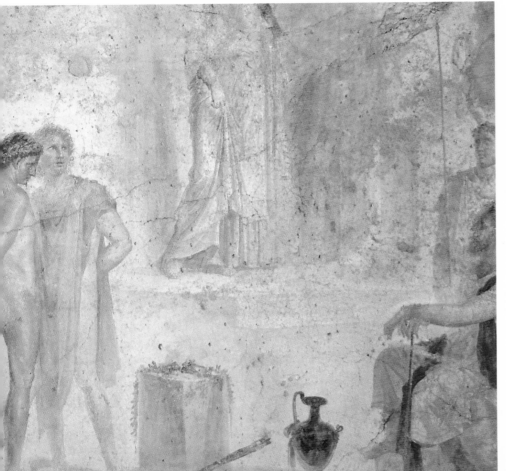

Baby Heracles

Pompeii VI.15.1, Casa dei Vettii, triclinium *n,*
North wall; Fourth Style

Alcmene's sons were Heracles, by Zeus, and Iphicles, by her husband Amphitryon. One night, she put the infants to bed in a bronze crib covered by a golden fleece. Around midnight, Hera, always ready to punish the infidelities of her husband, sent two snakes to Amphitryon's house to kill Heracles. The snakes slid along the marble floors and woke the sleeping babies.

Iphicles tried to flee, but Heracles threw himself on the snakes and strangled one in each hand, showing them to Amphitryon and Alcmene, who had rushed to help. This painting depicts the last portion of the story in an elaborate architectural framework. It derives from an original painting from the end of the fifth century B.C. attributed to the painter Zeuxis.

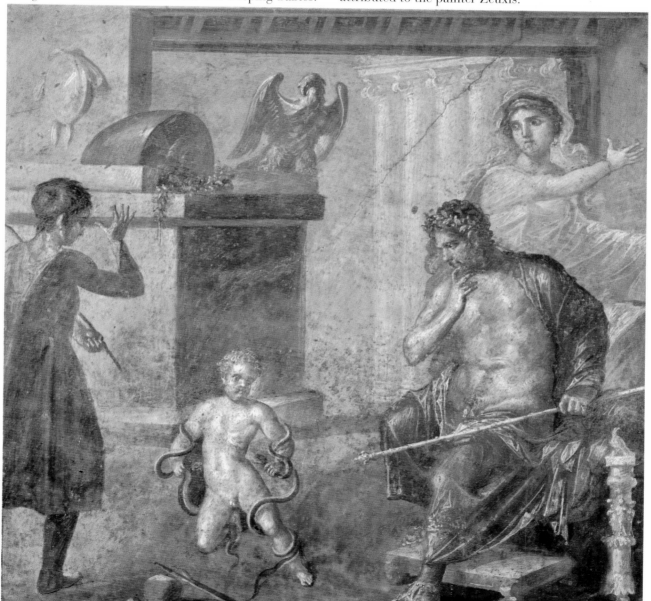

Heracles and Omphale

MANN inv. no. 9000
Pompeii VII.16.Ins. Occ., 10, Excavation of the Prince of Montenegro,
oecus *no. 6; Third Style*

Omphale, queen of Lydia, bought Heracles, intending to make him her lover rather than keeping him as a slave. Omphale's desire was fulfilled, and she bore three sons by Heracles. While Heracles remained in Lydia, the rumor spread throughout Greece that the hero had abandoned his club and lion's skin, loved to dress in women's clothes, and lived with Omphale's maidservants, timidly fulfilling the queen's every desire. These slanderous untruths originated when

Heracles and Omphale visited the vineyard of Tmolus. There they were spied on by Pan, the part-human, part-goat sylvan god. Struck by the beauty of the queen, Pan thought to make her his lover. When night arrived, Heracles and Omphale withdrew to a grotto. As a joke, they exchanged clothes, the hero accidentally tearing the queen's precious clothes in his attempt to put them on. After dinner, they retired to separate beds. At midnight, Pan crept into the grotto and in the dark silently approached what he thought, based on the richness of the clothes, was Omphale's couch. Raising the bedspread, he slipped inside. Heracles awoke and with a violent kick sent Pan flying against the wall of the grotto, thus awakening Omphale. By the light of the torches, the two lovers burst into laughter at the sight of Pan stretched out on the ground bruised and sore.

To take revenge for his embarrassment, Pan spread the rumor that Heracles liked to dress in women's clothes. This painting, and its analogous version in the *Casa di Sirico*, does not refer to a precise episode of the myth. Rather, it generically shows the drunken Heracles lying on the ground while Erotes play with his armor; above, Omphale, accompanied by her maidservants, watches the hero, whom she has already won over. The scene's allegorical significance is clear: it shows how easily a strong and courageous man can be seduced and enslaved by an ambitious and lascivious woman.

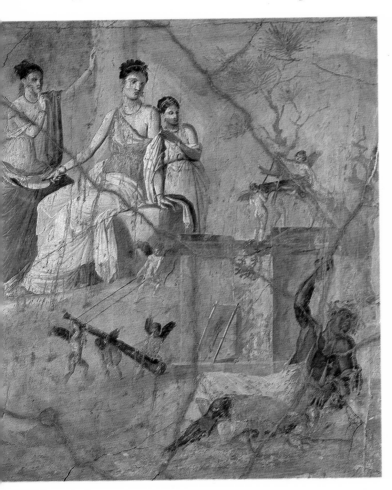

Heracles and Telephus

MANN inv. no. 9008 Herculaneum, Basilica

During a voyage Heracles stopped at Tegea. where he was received with friendship by the king, Aleus. He was invited to a banquet, during which he was struck by the beauty of Auge, the virgin daughter of the king and priestess of Athena. When all the guests had left, Heracles and Auge withdrew to an isolated spot outside the palace. In the months after Heracles' departure, Auge's pregnancy became impossible to conceal, and thus King Aleus learned of the sacrilege. He sent his daughter to King Nauplius with orders to kill her. During the journey, Auge was struck by labor pains and gave birth to a baby on Mount Parthenion. She hid the child in the bushes before continuing toward Nauplia where, instead of being killed, she was sold as a slave. Auge's son survived, thanks to a hind that suckled him. Later he was found by some herdsmen, who called him Telephus. This painting, perhaps derived from a Pergamene original dating to the late third or early second century B.C., includes various key elements of the story. Heracles, with his back to the viewer, observes Telephus, who is suckled by the hind; the personification of Arcadia appears in the background.

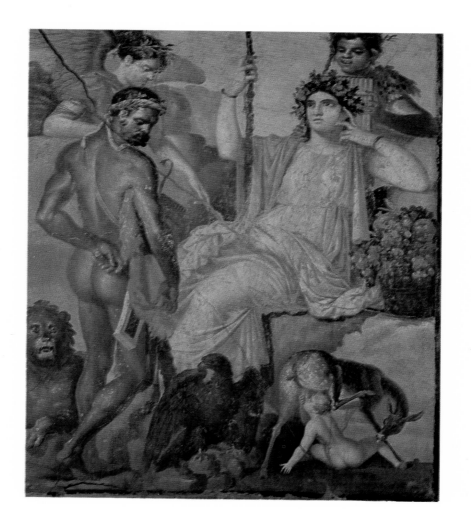

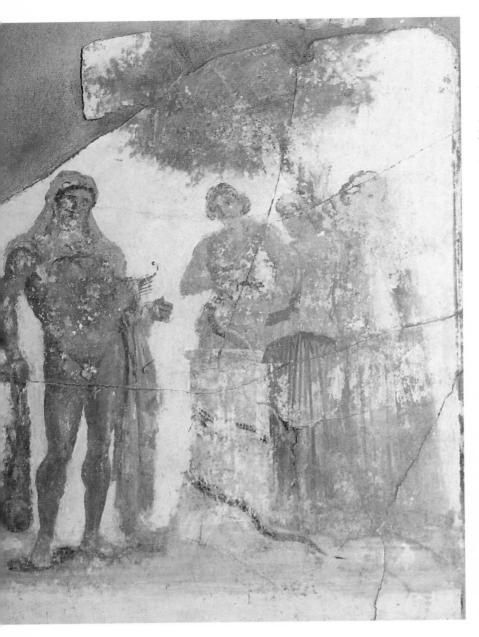

Heracles in the Garden of the Hesperides

Pompeii I.7.7, Casa del Sacerdos Amandus, triclinium *b, North wall; Third Style*

Eurystheus, who had formulated the Twelve Labors of Heracles, exacted as the eleventh labor the gathering of golden apples from an apple tree. The gift of Mother Earth (Ge) to Hera, the golden fruit was planted in a garden on the slopes of Mount Atlas. The tree was guarded by the Hesperides, daughters of Atlas, and by the dragon Ladon, who wound himself around the truck. As he journeyed to the Garden of the Hesperides, Heracles asked Nereus, god of the sea, for advice. Nereus exhorted Heracles not to gather the fruits with his own hands but to enlist the help of Atlas, relieving for a moment the weight of the celestial globe that rested on Atlas's shoulders. After Heracles had killed the dragon with an arrow, he asked this favor of Atlas, who, seeking respite from his terrible burden, immediately agreed. Heracles bore the weight of the sky while Atlas went away, returning after a few seconds with three apples harvested by his daughters. Happy to have regained his liberty, Atlas told the hero that he would carry the apples to Eurystheus. Heracles astutely pretended to agree. He asked Atlas to hold the globe momentarily while he protected his head with a pad. Atlas fell for the trick and, putting the apples on the ground, took back the globe. Heracles quickly grabbed the fruit and returned to Eurystheus. This wall painting depicts the conclusion of the exploit. Heracles stands on the left, the Hesperides are on the right, and the dragon, represented as a serpent, appears in the center. The prodigious apple tree is in the background.

Heracles and Nessus

MANN inv. no. 9001
Pompeii VI.9.3, Casa del Centauro,
tablinum no. 26, South wall;
Third Style

Heracles, together with his wife Deianeira and son Hyllus, arrived at the river Evenus during a flood. The Centaur Nessus, who was stationed there, offered to carry Deianeira to the other bank of the river while Heracles swam across. The hero accepted and, after throwing his club and bow to the other side, dove into the river. The Centaur, charmed by Deianeira, grabbed her, galloped off in the opposite direction, and tried to rape her. Heracles soon realized that he had been deceived. He retrieved his bow, took aim, and transfixed the body of Nessus with an arrow. Before dying, the Centaur whispered to Deianeira that her husband would always be faithful if she soaked his shirt in a mixture of the Centaur's semen spilt on the ground, the blood from his wound, and oil.

This composition, known from four other replicas, depicts the initial moment of the myth, with the Centaur kneeling so Deianeira can sit on his back. The painting is generally recognized as a reworked copy of a celebrated painting of Artemon, an East Greek painter of the first half of the third century B.C., conserved in the Portico of Octavia at Rome.

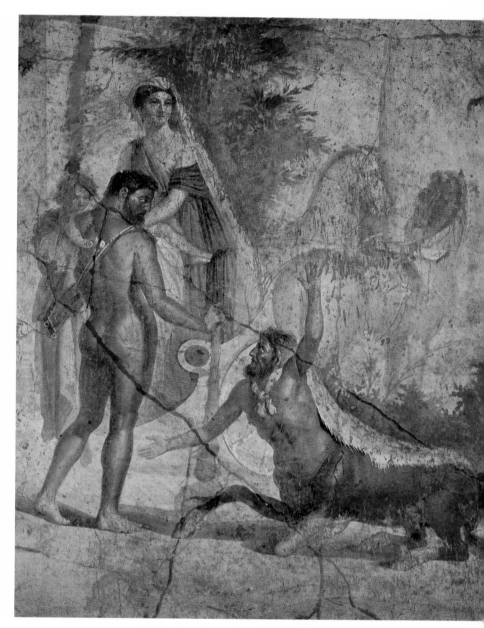

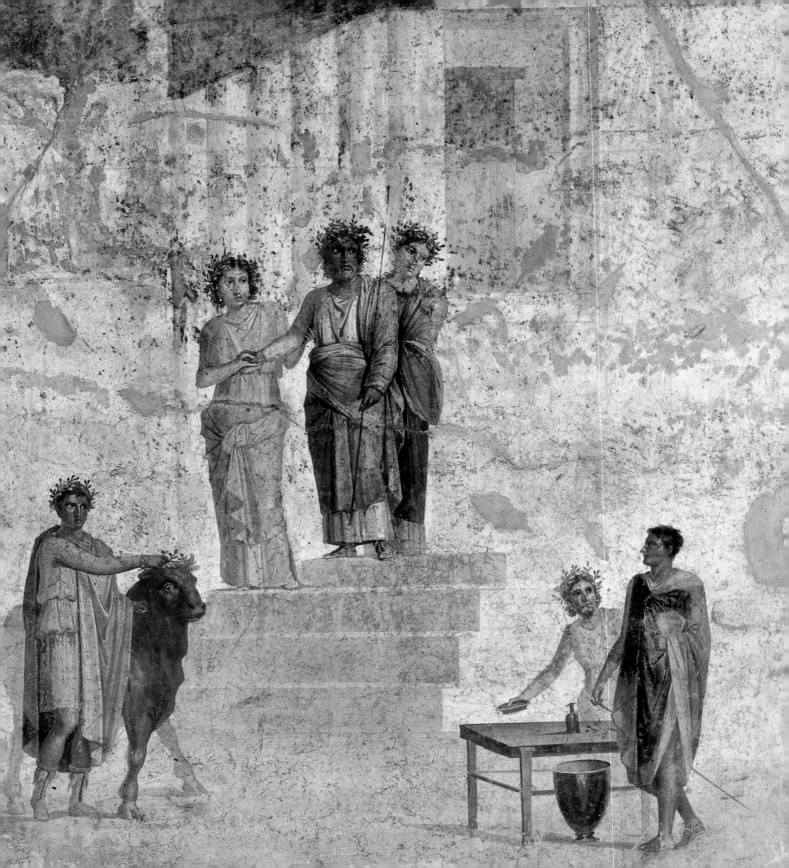

Jason and Pelias

MANN inv. no. 111436
Pompeii IX.5.18, Casa di Giasone, triclinium f,
West wall; Third Style

After the death of King Cretheus, Pelias seized the kingdom of Iolcus, imprisoning his stepbrother Aeson, the legitimate heir. Following an oracle's advice, Pelias eliminated all of the other possible pretenders. Aeson's wife, Polymela, saved their son Diomedes by making Pelias believe that he was dead; she hid Diomedes on Mount Pelius, where he was raised by the Centaur Chiron. A second oracle advised Pelias to beware of a man who wore only one sandal. Several years had gone by when Pelias and his daughters were performing a sacrifice on the seashore. A group of princes, his allies, arrived; among them was a man armed with two spears and only one sandal. Pelias, remembering the oracle, asked his name. The youth responded that Chiron, his adoptive father, had called him Jason but that in fact he was Diomedes, the son of Aeson. In this Pompeian composition, perhaps derived from a late Hellenistic original, King Pelias and his two daughters stand in the center; on the left, the bull awaits the sacrifice; on the right, Jason reveals his identity, interrupting the action of all the figures.

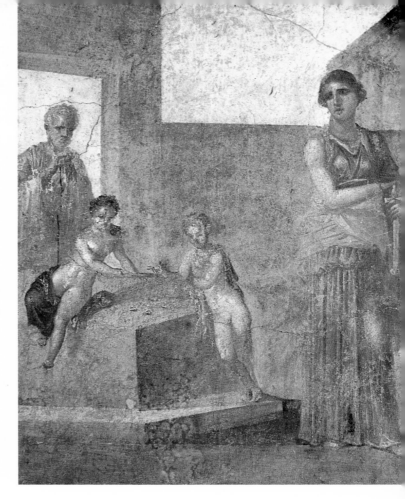

Medea

MANN inv. no. 8977
Pompeii VI.9.6, Casa dei Dioscuri, peristyle no.
53, NE pilaster; Fourth Style

Jason married Medea, the only surviving daughter of Aeëtes of Corinth, becoming sovereign of the city. After he had reigned for ten years, however, Jason began to suspect that his wife had ensured his succession to the throne through homicide. To legitimize his power, he planned to divorce Medea and to marry Glauce, a Corinthian woman. Medea pretended to be resigned to her fate and had her sons bring a white mantle and a gold crown to Glauce as wedding gifts. As soon as Glauce put the gifts on, huge flames arose and devoured the ill-fated woman. Zeus himself, admiring Medea's courage, fell in love with her, but his proposals were rejected. A grateful Hera offered to make Medea's sons immortal if she sacrificed them in her honor. Medea obeyed, then fled Corinth. The painting shown here probably derives from an original by Timomachos, who is believed to have been active either in the fourth century B.C. or around the middle of the first century B.C.

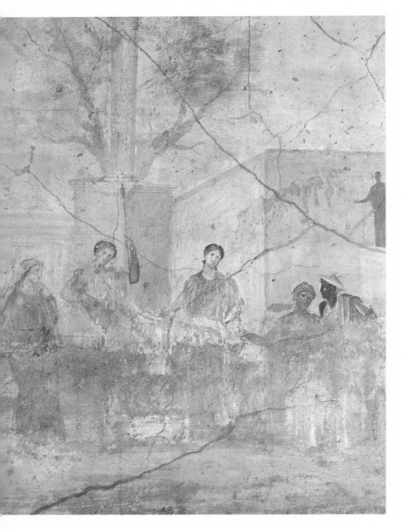

Judgment of Paris
MANN inv. no. 120033
Pompeii I.4.5, Casa del Citarista, room no. 21,
North wall; Third Style

During the banquet for the marriage of Peleus and Thetis, Eris (Strife) threw a golden apple onto the table inscribed with the words "To the most beautiful." A dispute arose among Hera, Athena, and Aphrodite. To settle the quarrel, Zeus instructed Hermes to convey the three women to Mount Ida, where Paris, the son of Priam, was pasturing a flock. The youth was unaware of his noble origins. He had been abandoned at birth on Mount Ida because it had been foretold to Priam that he would be the cause of Troy's destruction. After Hermes had explained Zeus's orders, Paris passed the apple from one hand to the other, then asked the three goddesses to undress so that he could examine them up close. The goddesses agreed. One by one, they approached Paris, almost so as to touch him, each making a tempting promise. Hera promised a kingdom and immeasurable riches. Athena offered to make him the wisest and most handsome of men as well as invincible in war. Aphrodite vowed to help him marry Helen of Troy, the most beautiful among women. Paris, attracted by this last promise, consigned the apple to Aphrodite. Thus, he aroused the hatred of Hera and Athena, who immediately began thinking about how to punish him.

Achilles and Chiron
MANN inv. no. 9109
Herculaneum, Basilica

As soon as he was born, Achilles was immersed by his mother, Thetis, in the river Styx. This made his body invulnerable—except for the heel by which he was held. Later, Achilles was consigned by his father, Peleus, to the Centaur Chiron, who was to raise him and render him strong and courageous. The Centaur instructed Achilles in the arts of horseback riding and hunting, and also taught him how to play musical instruments and cure wounds.

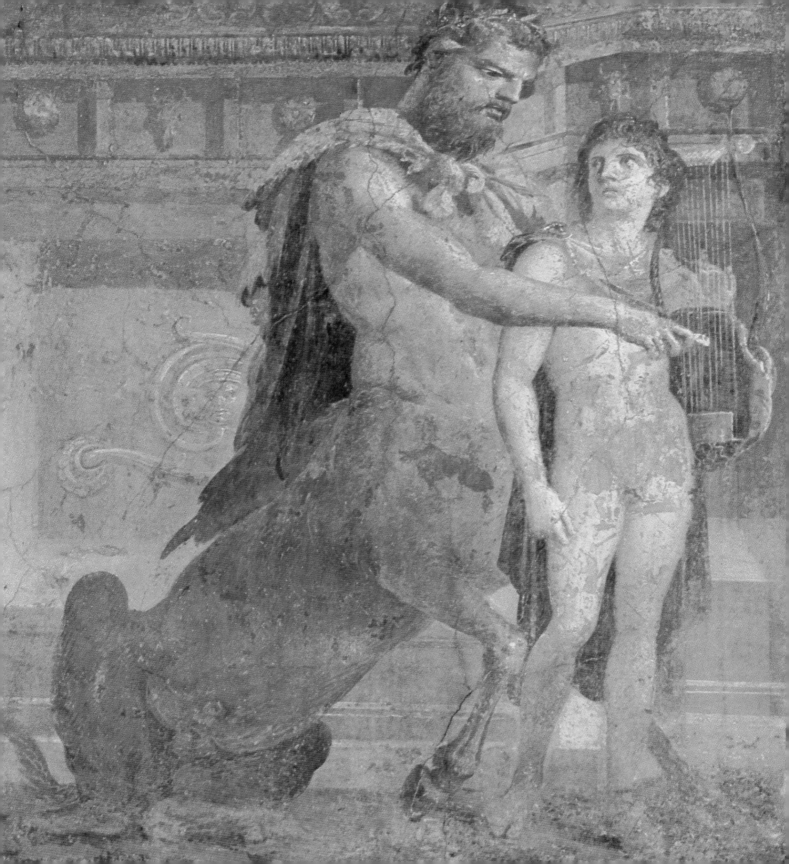

Achilles at Scyros

MANN inv. no.116085
Pompeii IX.5.2, Casa di Giasone, triclinium f, South wall;
Third Style

Thetis, mother of Achilles, knew that if her son participated in the war against Troy he would never return alive. For this reason, she entrusted him to Lycomedes, king of Scyros. There Achilles lived in the palace disguised as a woman. In one of his oracles, Calchas predicted, however, that only with the help of young Achilles would the city of Troy be conquered. The task of finding Achilles fell to Odysseus, Nestor, and Ajax. They went immediately to Scyros because it was rumored that Achilles was hidden in that place. Lycomedes allowed the three heroes to enter the palace. Odysseus asked to see the girls of the court to offer precious gifts as a sign of friendship. While the girls were intent on choosing their gifts, a fight was staged outside the room. One of the "girls" immediately took from the gifts a shield and lance, thus revealing himself to be Achilles. The painting shown here depicts this agitated scene, but the copyist's rather unpleasant rendering of the bodies' anatomy certainly does not reflect the beauty of the fourth-century-B.C. original upon which it is based.

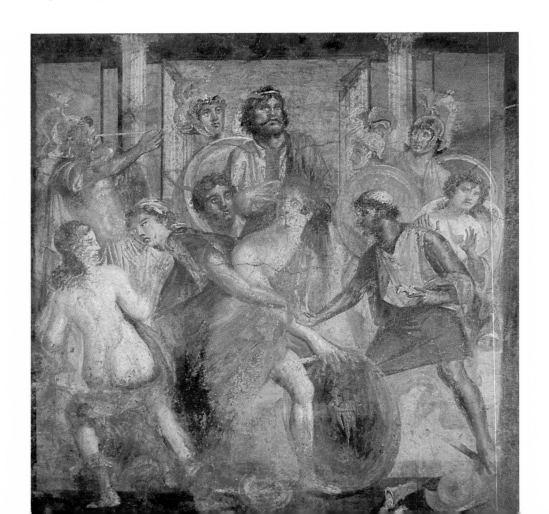

Sacrifice of Iphigenia
MANN inv. no. 9112
Pompeii VI.8.3, Casa del Poeta Tragico, peristyle no. 10, North wall of the portico;
Fourth Style

When the Greek fleet assembled for the second time at Aulis, strong countervailing winds prevented it from setting sail for Troy. Calchas prophesied that only if Agamemnon sacrificed Iphigenia, the most beautiful of his daughters, to Artemis, would the ships be able to depart for the expedition. After attempting to resist, a desperate Agamemnon agreed, and Iphigenia herself was resigned to die for the glory of Greece. In this painting, Agamemnon stands on the left with his head covered to hide his grief; in the center, Odysseus and Diomedes lead Iphigenia to sacrifice; on the right, the seer Calchas looks on. The story's happy epilogue is referenced in the scene above, as Artemis arrives, along with a nymph who brings a deer to sacrifice in the girl's place. Iphigenia will be transported by Artemis to the goddess's sanctuary in Tauris, where she will encounter her brother Orestes. This painting may derive, at least in part, from a painted original by Thimanthes I, who was active about 400 B.C.

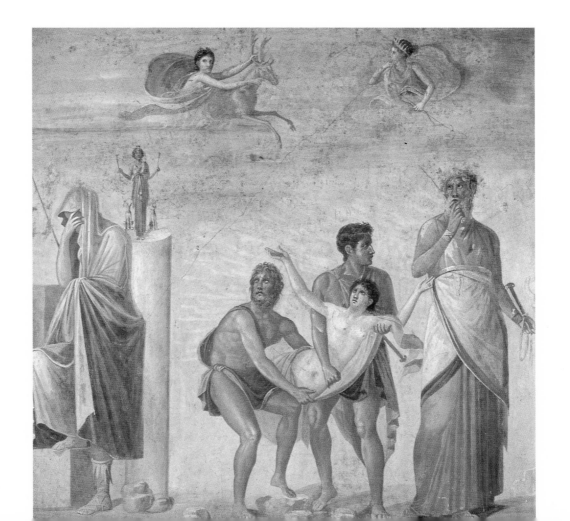

Achilles and Briseis

MANN inv. no. 9105

Pompeii VI.8.3, Casa del Poeta Tragico, atrium no. 3, South wall; Fourth Style

After handing back the beautiful Chryseis to her father Chryses, Agamemnon forced Achilles to return Briseis, the daughter of Calchas. A furious Achilles obeyed, but declared that he and his army would abstain from fighting the famous Myrmidons. The Trojans took advantage of Achilles' neutrality and, after repeated skirmishes with variable results, eventually succeeded in arriving at the ships of the Greeks and began to burn them. At that point, Achilles forgot his rancor and drove his army against the Trojans, pushing them back inside the city. This painting, perhaps the most beautiful copy of a Greek original found in the Vesuvian area, shows Achilles, seated, taking leave of Briseis, whom Patroclus, seen from behind, leads out of the tent toward Agamemnon's heralds. Achilles' head is reflected in extraordinary detail on the background of one of the soldiers' shields.

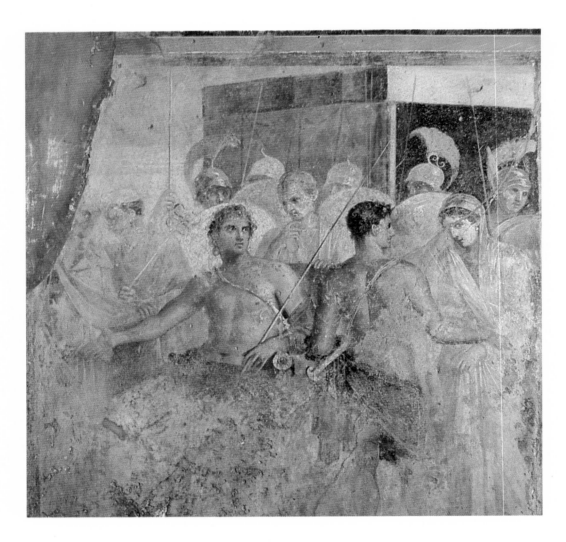

The Wooden Horse, Laocoön, The Sack of Troy
Pompeii I.10.4, Casa del Menandro, ala no. 4, East, South, North walls; Fourth Style

These three paintings depict the salient moments of the end of Troy. In the first, we see the famous wooden horse that the Greeks constructed, inspired by Athena. In the background, the walls of the city have already been knocked down; in the foreground, the prophetess Cassandra is led away after having uselessly predicted that the horse contained within it the Greeks. The second painting portrays the death of Laocoön; he too had tried to warn the Trojans that there were Greeks hidden inside the horse. After throwing a spear that had made the womb of the horse vibrate to no avail, the seer was preparing to sacrifice a bull to Poseidon when two serpents emerged from the sea. The snakes coiled themselves around Laocoön and his sons, crushing them. Priam convinced himself that Laocoön had been punished in this terrible way because he had hurled the spear against the horse sacred to Athena. Thus, he gave his approval to bring the horse within the city, beginning

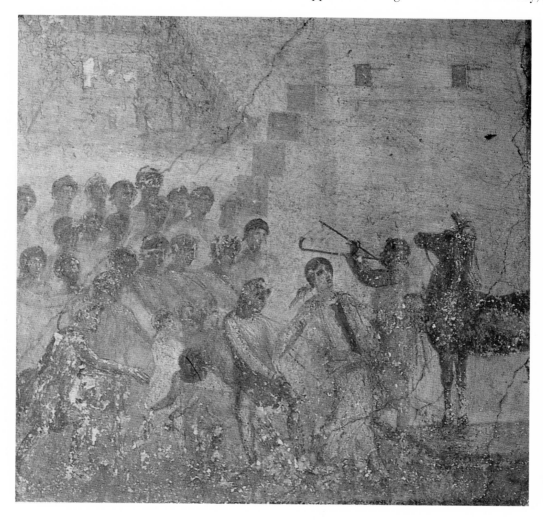

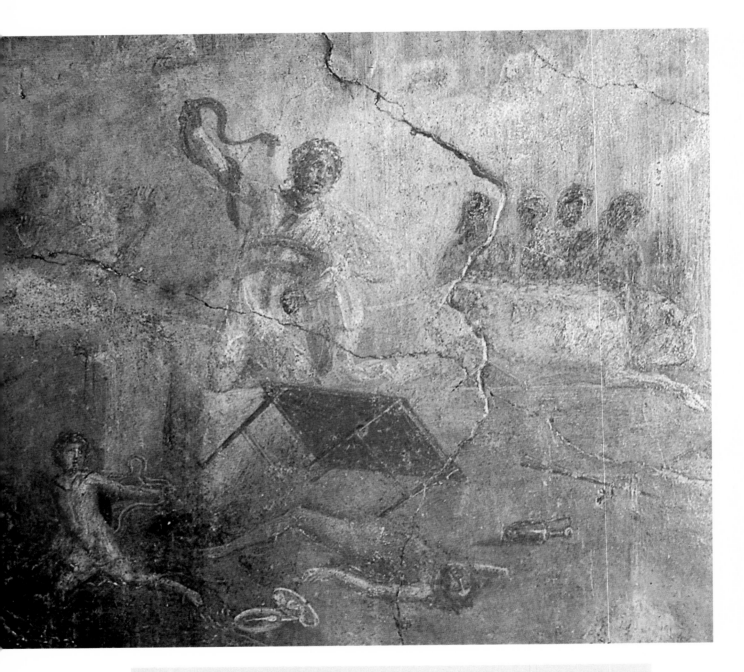

CALCHAS HAD PREDICTED THAT IF YOU PROFANE THIS IMAGE,
ATHENA WILL DESTROY TROY; BUT IF IT WILL STAND ON YOUR
CITADEL, YOU WILL EXTEND YOUR POWER IN ALL OF ASIA, INVADE
GREECE, AND CONQUER MYCENAE.

VIRGIL, *AENEID*

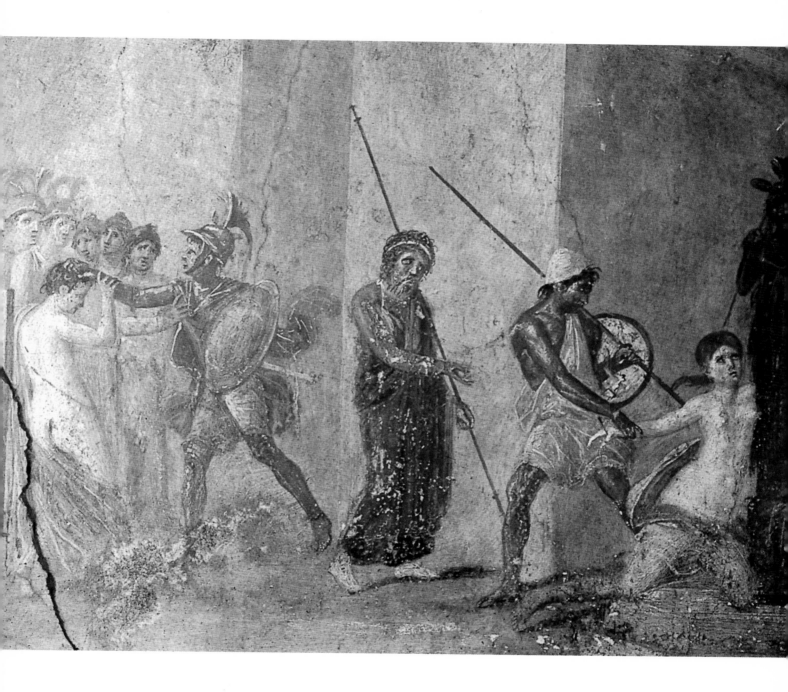

celebrations that continued late into the night. Around midnight, while the Trojans slept, the Greeks descended from the horse, opening Troy's gates to the rest of the army that waited outside. The third painting depicts one of the episodes of the sack of Troy. Priam is in the center; on the left, Menelaus seizes Helen by the hair; on the right, Cassandra, embracing the image of the Palladium, is shown with Ajax, who tries to drag her away.

Various authors. *La pittura di Pompei,* Milan, 1991.

Augusti, S. *I colori pompeiani.* Rome, 1967.

De Carolis, E. *Pittori greci.* Rome, 1989.

Graves, R. *The Greek Myths.* New York, 1960.

Maiuri, A. *La Peinture Romaine.* Florence, 1953.

The Elder Pliny's Chapters on the History of Art (trans. K. Jex-Blake). Chicago, 1977.

Pompeii, Picta Fragmenta (exhibition catalogue). Turin, 1997.

Pompei, Pitture e Mosaici I–VIII. Rome, 1990–1998.

Ragghianti, C.L. *Pittori di Pompei.* Milan, 1963.

Romana Pictura (exhibition catalogue). Venice, 1998.

Vitruvius. *Ten Books on Architecture* (trans. I.D. Rowland). Cambridge, 1999.

BIBLIOGRAPHY